10 STEP DRAWING

Animals

DRAW ⑦⑤ ANIMALS IN 10 EASY STEPS

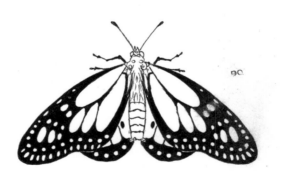

Heather Kilgour

Contents

INTRODUCTION 6

HOW TO USE THIS BOOK....................... 7

⫸ Wild Animals

Cheetah.. 10

Bald Eagle ... 12

Lemur ... 14

Hippopotamus 15

Giraffe .. 16

Elephant .. 18

Lion .. 20

Chameleon... 22

Armadillo ...24

Crocodile.. 25

Rhinoceros... 26

Meerkat .. 27

Gorilla .. 28

Giant Panda .. 30

Antelope...32

Kangaroo.. 34

Zebra.. 35

Tiger ... 36

Chimpanzee ... 38

Koala .. 39

Platypus.. 40

Dung Beetle.. 41

Anteater..42

Sloth.. 43

⫸ Aquatic Animals

Blue Whale...46

Common Seal...48

Goldfish.. 49

Great White Shark.................................

Lobster..

Sea Turtle...

Crab.. 55

Orca ... 56

Seahorse... 58

Penguin .. 60

Octopus...61

Polar Bear .. 62

Blue Tang.. 64

Jellyfish... 65

Dolphin .. 66

Walrus .. 68

Hammerhead Shark................................70

>>> Woodland Animals

Fox...74

Snail...76

Bumblebee 77

Deer...78

Frog ... 80

Wolf ... 82

Raccoon... 84

Red Squirrel 85

Elk ... 86

Ladybird.. 88

Beaver ... 89

Grizzly Bear................................... 90

Owl .. 92

Skunk... 94

Bat ... 95

Butterfly.. 96

River Otter 98

>>> Farm Animals & Pets

Cow ... 102

Donkey... 104

Rabbit ... 106

Sheep ...107

Dog... 108

Budgerigar 110

Guinea Pig.....................................111

Pig.. 112

Camel ... 114

Goat ... 116

Snake.. 117

Horse.. 118

Mouse...120

Duck ... 121

Llama ..122

Cat.. 124

Chicken...126

ABOUT THE ARTIST128

ACKNOWLEDGEMENTS128

Introduction

In this book you will find 75 inspirational animal illustrations which have been created in just 10 simple steps. Whether it's a galloping horse, a sleeping cat or a cute penguin, it's time to choose your favourite animal and get drawing.

Drawing animals is easier than you think because many of them share the same basic body features – a skull, rib cage, limbs and a spine. Breaking the drawing down into these elements will help you place them in the correct position.

TACKLING PROPORTIONS

I have included the head as a unit of measurement in some of the images. For example, a giraffe has a neck that is 2½ times the length of its face and is the same length as its legs. The head can also be divided up to show where the features should be placed, so I have included these guides to help you place some of the difficult facial features. If needed,

where guides have not been provided, you can measure the finished drawing in this book with a ruler and use the measurements to create a grid. Simply, use this to help you copy the proportions and erase the grid when you've finished.

Time spent comparing the size of the body parts for different animals will help you to capture the subtle but essential visual difference between animals. For example, a cow's body and legs make up equal parts of its height but a donkey has slightly longer legs in comparison to its body.

I hope you will enjoy creating the animals in this book as much as I did. Drawing has never been easier!

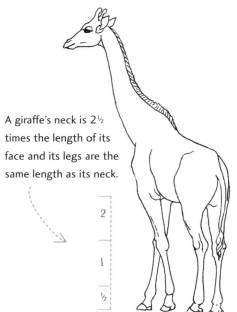

A giraffe's neck is 2½ times the length of its face and its legs are the same length as its neck.

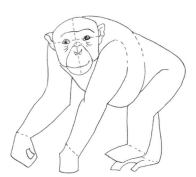

How to use this book

BASIC EQUIPMENT

Paper: any paper will do but using sketch paper will give you the best results.

Pencil, eraser and pencil sharpener: try different pencil grades and invest in a good-quality eraser.

Pen: for inking the final image. A medium or fine ink pen is best (ink is better than ballpoint because it dries quickly and is less likely to smudge).

Small ruler: this is optional, but you may find it useful for drawing guidelines.

FOLLOWING THE STEPS

Use pencil and follow each step. When you are happy with the animal, draw over it in ink, let it dry and then erase the underlying pencil. Finally, apply colour as you like.

COLOURING

Stay inside the lines and keep your pencils sharp so you have control in the smaller areas.

To achieve a lighter or darker shade, try layering the colour or pressing harder with your pencil.

Many animals come in different colours and have different patterns, so once you're confident with where the shading should be on each animal, why not try varying the animal's coat?

You have several options when it comes to colouring your drawings – why not explore them all?

Pencils: this is the simplest option, and the one I have chosen for finishing the pictures in this book. A good set of coloured pencils, with about 24 shades, is really all you need.

Paint and brush: watercolour is probably easiest to work with for beginners, although using acrylic or oil means that you can paint over any mistakes. You'll need two or three brushes of different sizes, with at least one very fine brush.

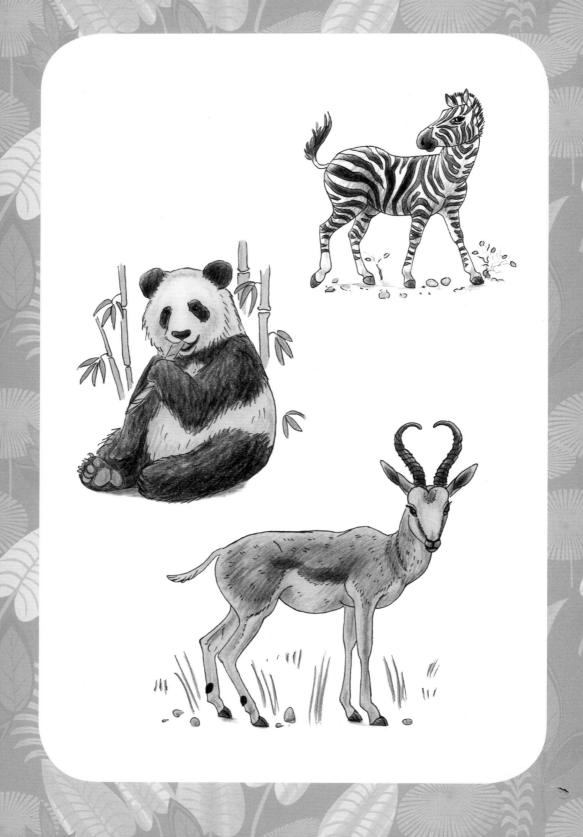

Wild Animals

Cheetah

The cheetah is the fastest-running land animal, characterised by its slender body and spotted coat. Use angled lines in your drawing to give the illusion that the cheetah is moving fast.

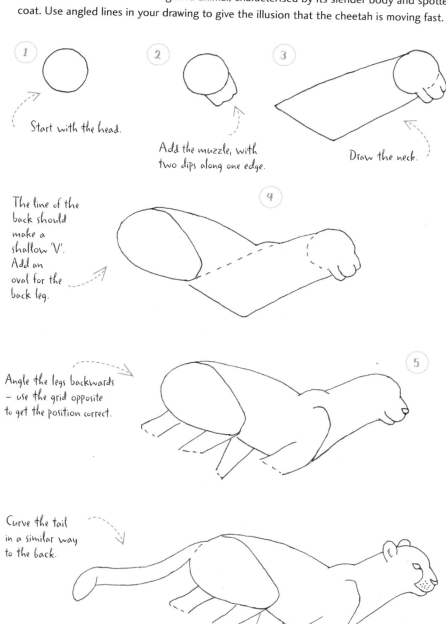

1 Start with the head.

2 Add the muzzle, with two dips along one edge.

3 Draw the neck.

The line of the back should make a shallow 'V'. Add an oval for the back leg.

4

Angle the legs backwards – use the grid opposite to get the position correct.

5

Curve the tail in a similar way to the back.

6

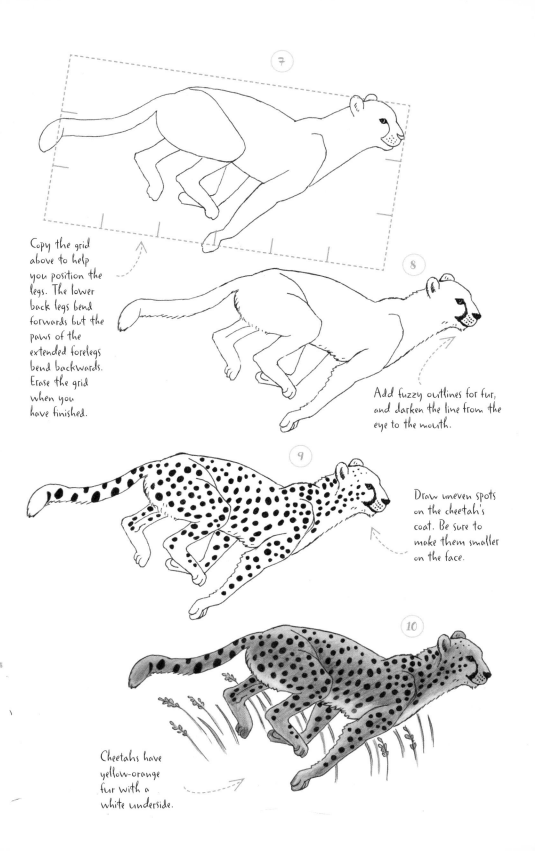

Copy the grid above to help you position the legs. The lower back legs bend forwards but the paws of the extended forelegs bend backwards. Erase the grid when you have finished.

Add fuzzy outlines for fur, and darken the line from the eye to the mouth.

Draw uneven spots on the cheetah's coat. Be sure to make them smaller on the face.

Cheetahs have yellow-orange fur with a white underside.

Bald Eagle

A bald eagle's smallest feathers are on its head and its longest feathers are on its wing tips and tail. You can tell that it is a predatory species by its large beak and claws.

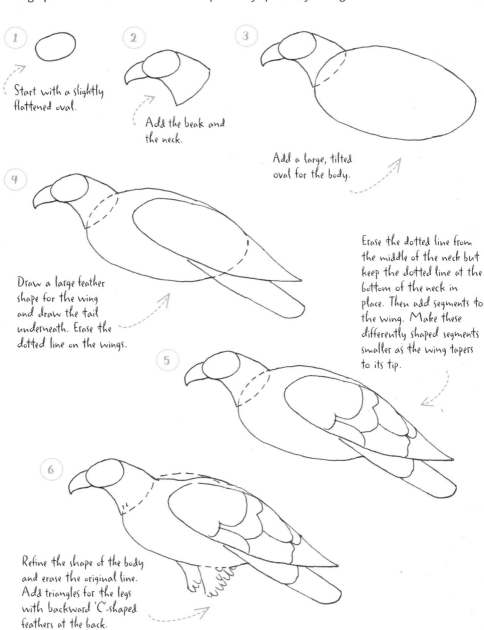

① Start with a slightly flattened oval.

② Add the beak and the neck.

③ Add a large, tilted oval for the body.

④ Draw a large feather shape for the wing and draw the tail underneath. Erase the dotted line on the wings.

Erase the dotted line from the middle of the neck but keep the dotted line at the bottom of the neck in place. Then add segments to the wing. Make these differently shaped segments smaller as the wing tapers to its tip.

⑤

⑥ Refine the shape of the body and erase the original line. Add triangles for the legs with backward 'C'-shaped feathers at the back.

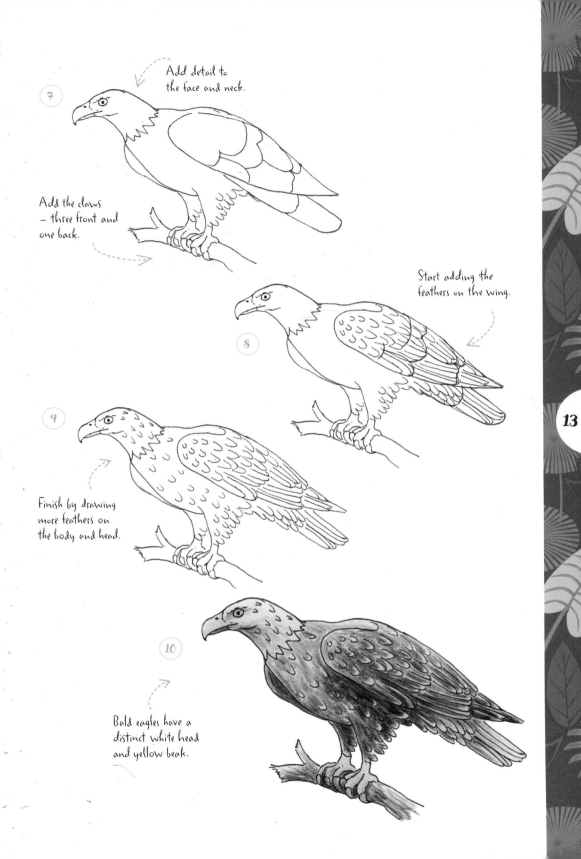

7 Add detail to the face and neck.

Add the claws — three front and one back.

8 Start adding the feathers on the wing.

9 Finish by drawing more feathers on the body and head.

10 Bald eagles have a distinct white head and yellow beak.

Lemur

Lemurs have human-like fingers and toes (although they are a little bit longer!).
If you can't get them quite right, why not try copying your own?

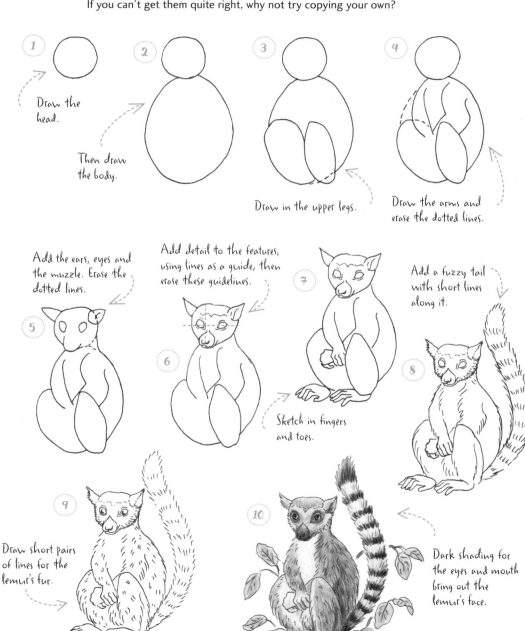

1

Draw the head.

2

Then draw the body.

3

Draw in the upper legs.

4

Draw the arms and erase the dotted lines.

5

Add the ears, eyes and the muzzle. Erase the dotted lines.

6

Add detail to the features, using lines as a guide, then erase these guidelines.

7

Sketch in fingers and toes.

8

Add a fuzzy tail with short lines along it.

9

Draw short pairs of lines for the lemur's fur.

10

Dark shading for the eyes and mouth bring out the lemur's face.

Hippopotamus

Hippos spend a lot of time in the water, so if you want to add a background to your image, you could try adding its watery environment.

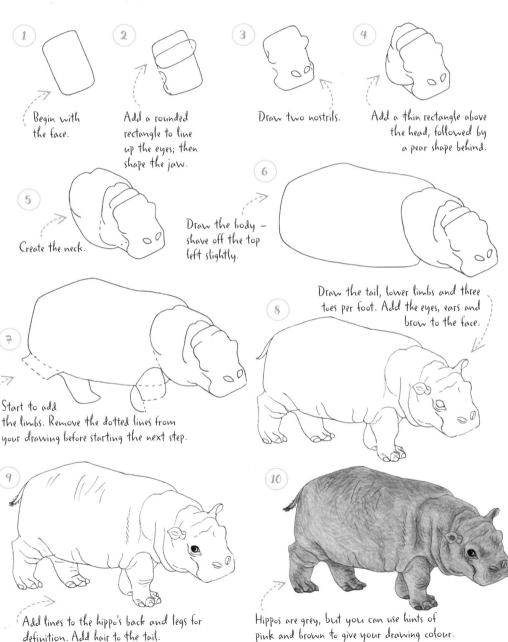

1. Begin with the face.

2. Add a rounded rectangle to line up the eyes; then shape the jaw.

3. Draw two nostrils.

4. Add a thin rectangle above the head, followed by a pear shape behind.

5. Create the neck.

6. Draw the body – shave off the top left slightly.

7. Start to add the limbs. Remove the dotted lines from your drawing before starting the next step.

8. Draw the tail, lower limbs and three toes per foot. Add the eyes, ears and brow to the face.

9. Add lines to the hippo's back and legs for definition. Add hair to the tail.

10. Hippos are grey, but you can use hints of pink and brown to give your drawing colour.

Giraffe

Giraffes are the tallest living animal. Make sure you get the proportions of the neck and legs right to show its height.

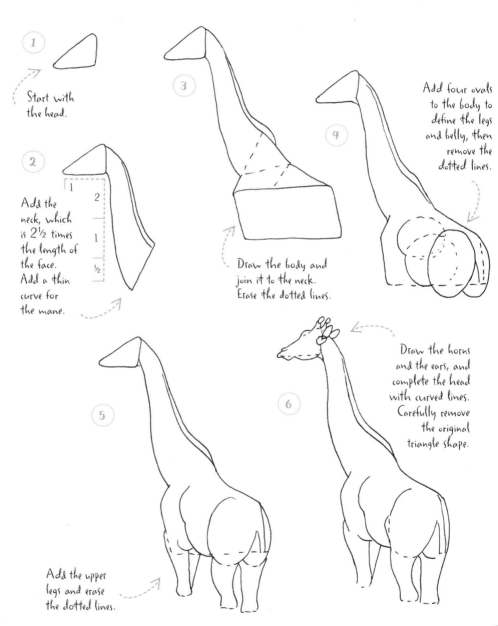

1 Start with the head.

2 Add the neck, which is 2½ times the length of the face. Add a thin curve for the mane.

3 Draw the body and join it to the neck. Erase the dotted lines.

4 Add four ovals to the body to define the legs and belly, then remove the dotted lines.

5 Add the upper legs and erase the dotted lines.

6 Draw the horns and the ears, and complete the head with curved lines. Carefully remove the original triangle shape.

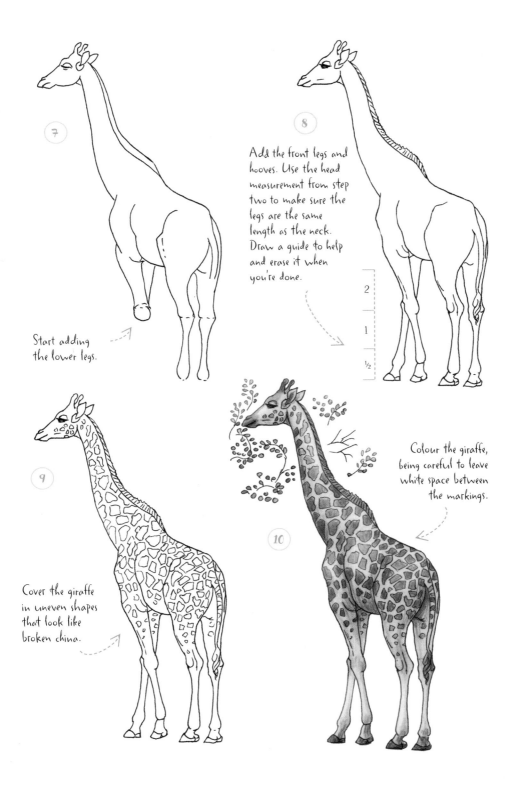

7

Start adding
the lower legs.

8

Add the front legs and
hooves. Use the head
measurement from step
two to make sure the
legs are the same
length as the neck.
Draw a guide to help
and erase it when
you're done.

2

1

½

9

Cover the giraffe
in uneven shapes
that look like
broken china.

10

Colour the giraffe,
being careful to leave
white space between
the markings.

Elephant

Elephants are impressive in their stature, and lovable thanks to their distinctive features. Pay particular attention to the shape of the ears and the curve of the trunk.

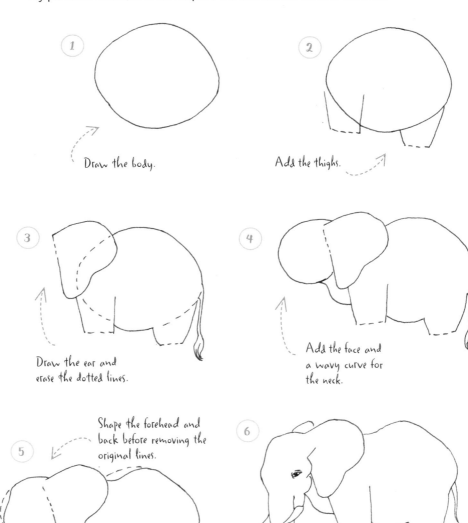

1

Draw the body.

2

Add the thighs.

3

Draw the ear and erase the dotted lines.

4

Add the face and a wavy curve for the neck.

5

Shape the forehead and back before removing the original lines.

6

Add the other ear. Then draw an eye, two tusks and a bulge for the cheek.

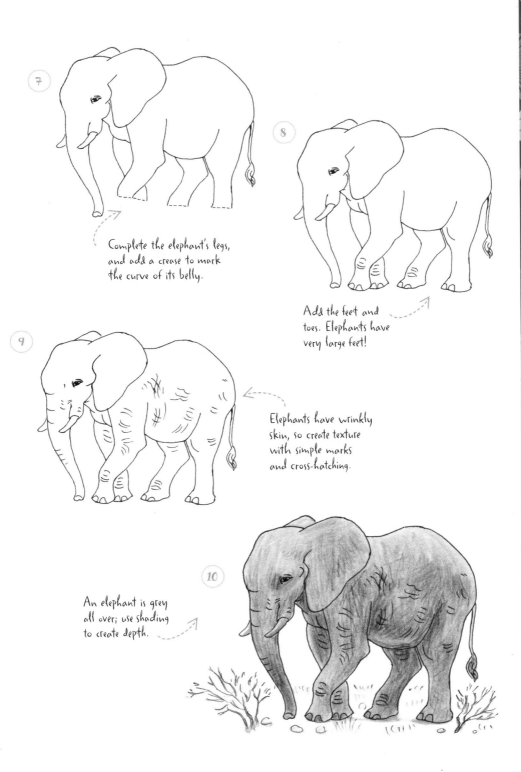

7

Complete the elephant's legs, and add a crease to mark the curve of its belly.

8

Add the feet and toes. Elephants have very large feet!

9

Elephants have wrinkly skin, so create texture with simple marks and cross-hatching.

10

An elephant is grey all over; use shading to create depth.

Lion

Thanks to the male lion's impressive mane, the lion's face
is one of the most widely recognised animal symbols.

①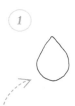

Start with a
teardrop shape.

②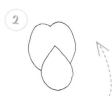

Then add a soft
oval, slightly curved
at the top.

③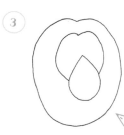

For the mane,
draw a bigger
oval around the
first two shapes,
again with a
curved top.

④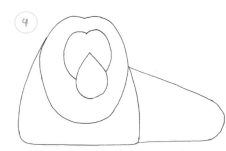

Draw the body, and add the
shoulders and folded front legs.

⑤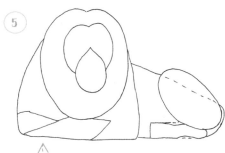

Mark the position of the
folded front paws. Draw
the back leg and remove the
dotted lines.

⑥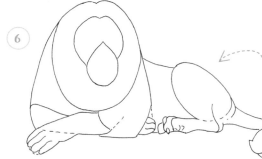

Complete the paws,
adding lines for the
toes. Then remove the
dotted lines before
adding the tail.

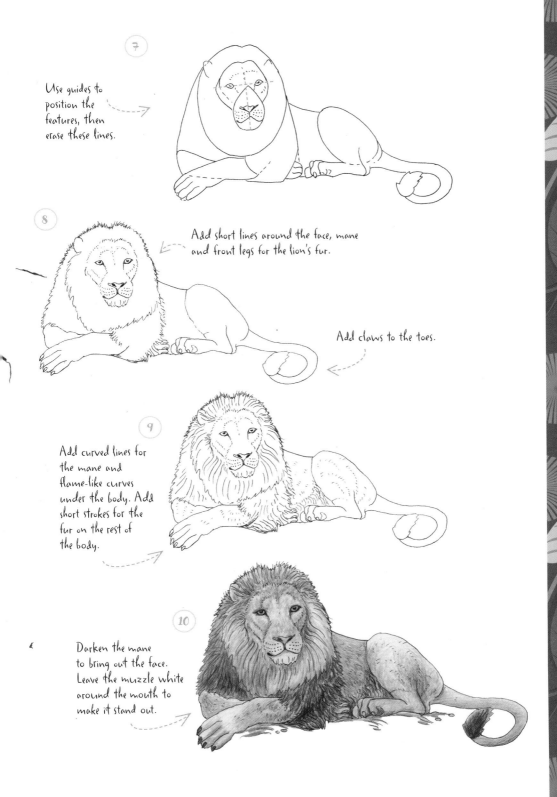

7 Use guides to position the features, then erase these lines.

8 Add short lines around the face, mane and front legs for the lion's fur.

Add claws to the toes.

9 Add curved lines for the mane and flame-like curves under the body. Add short strokes for the fur on the rest of the body.

10 Darken the mane to bring out the face. Leave the muzzle white around the mouth to make it stand out.

Chameleon

Chameleons have spiky skin. Make sure that you add the spikes carefully along the lines of your drawing to make the shape really stand out.

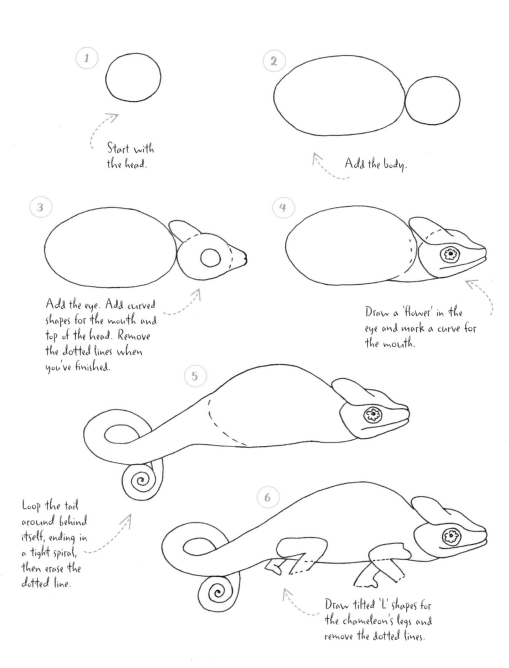

1

Start with the head.

2

Add the body.

3

Add the eye. Add curved shapes for the mouth and top of the head. Remove the dotted lines when you've finished.

4

Draw a 'flower' in the eye and mark a curve for the mouth.

5

Loop the tail around behind itself, ending in a tight spiral, then erase the dotted line.

6

Draw tilted 'L' shapes for the chameleon's legs and remove the dotted lines.

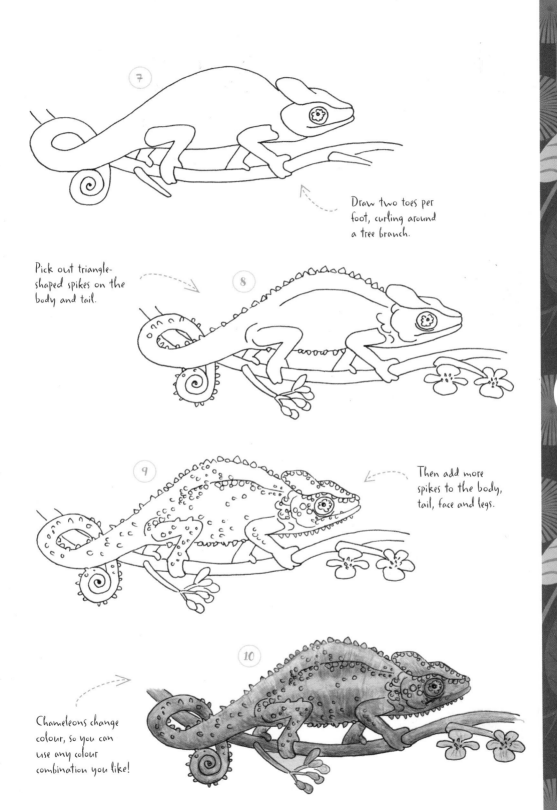

Draw two toes per foot, curling around a tree branch.

Pick out triangle-shaped spikes on the body and tail.

Then add more spikes to the body, tail, face and legs.

Chameleons change colour, so you can use any colour combination you like!

Armadillo

Armadillos are easy to draw because they are covered in a curved armour plate, which is decorated with a simple and repetitive pattern of scales.

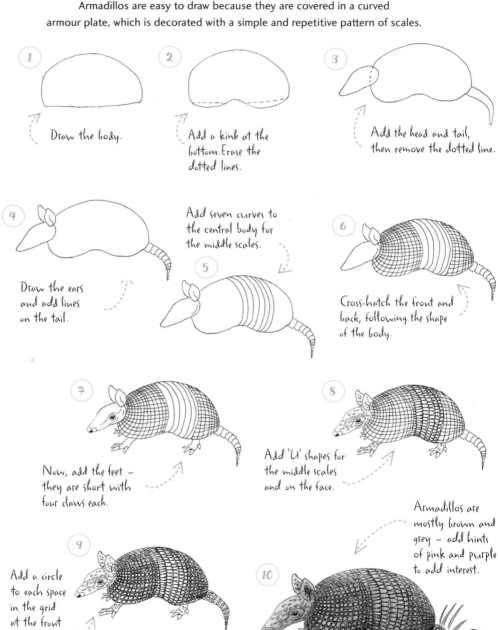

1 Draw the body.

2 Add a kink at the bottom. Erase the dotted lines.

3 Add the head and tail, then remove the dotted line.

4 Draw the ears and add lines on the tail.

Add seven curves to the central body for the middle scales.

5

6 Cross-hatch the front and back, following the shape of the body.

7 Now, add the feet – they are short with four claws each.

8 Add 'U' shapes for the middle scales and on the face.

Armadillos are mostly brown and grey – add hints of pink and purple to add interest.

9 Add a circle to each space in the grid at the front and back.

10

Crocodile

Crocodiles are aquatic reptiles with webbed feet and sharp teeth. Their eyes, ears and nostrils are positioned on top of the head, so they can lie low in water.

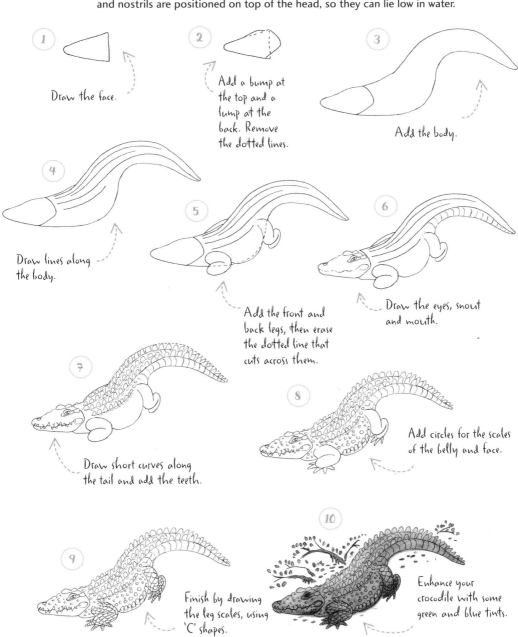

1. Draw the face.

2. Add a bump at the top and a lump at the back. Remove the dotted lines.

3. Add the body.

4. Draw lines along the body.

5. Add the front and back legs, then erase the dotted line that cuts across them.

6. Draw the eyes, snout and mouth.

7. Draw short curves along the tail and add the teeth.

8. Add circles for the scales of the belly and face.

9. Finish by drawing the leg scales, using 'C' shapes.

10. Enhance your crocodile with some green and blue tints.

Rhinoceros

Rhinos have large, stout bodies and short legs. Make sure to add bumps to the body to give it a natural shape.

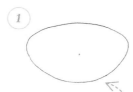

1 Start with an oval.

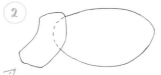

2 Then add the face. Remove the dotted line when you're done.

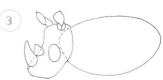

3 Add ovals and cones for the ears, tusks and eye. Erase the dotted lines.

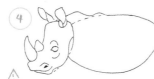

4 Connect the head and body, removing the original line. Add the mouth, nose and a narrow oval for the eye.

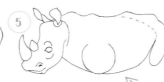

5 Start the front and back legs, then remove the dotted line.

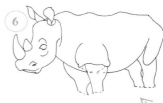

6 The front and hind legs are wide at the top but taper to become narrower above the feet.

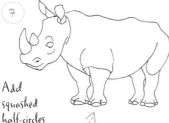

7 Add squashed half-circles for the toes.

8 Add wrinkles to the body, and fill in the eye and nostril.

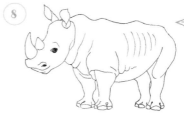

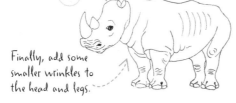

9 Finally, add some smaller wrinkles to the head and legs.

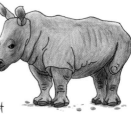

10 Rhinos are mostly grey. Use shading and a little bit of colour to bring out the shape.

Meerkat

The meerkat has a straight, narrow body.
Simple lines denote the limbs and tail.

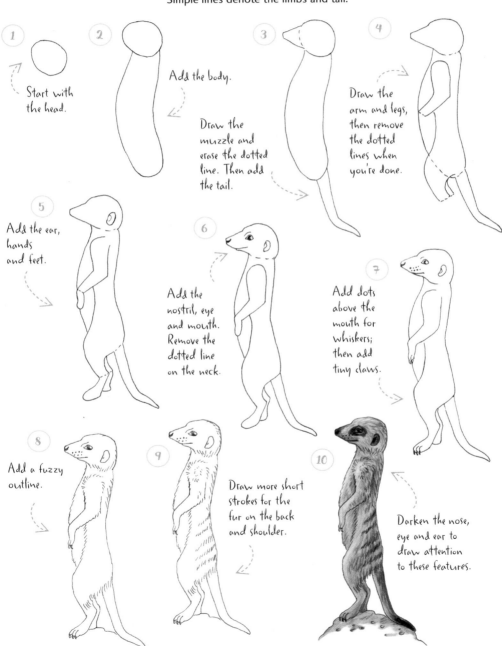

1 Start with the head.

2 Add the body.

Draw the muzzle and erase the dotted line. Then add the tail.

3

4 Draw the arm and legs, then remove the dotted lines when you're done.

5 Add the ear, hands and feet.

6 Add the nostril, eye and mouth. Remove the dotted line on the neck.

7 Add dots above the mouth for whiskers; then add tiny claws.

8 Add a fuzzy outline.

9 Draw more short strokes for the fur on the back and shoulder.

10 Darken the nose, eye and ear to draw attention to these features.

Gorilla

Gorillas often move around by walking on their knuckles, so make
sure you give your gorilla muscular arms and large hands.

①

Start with the face.

②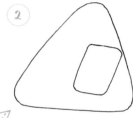

Add the head and shoulders.

③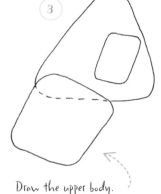

Draw the upper body.

④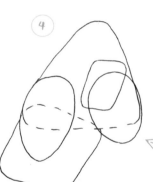

Draw egg shapes for
the tops of the arms.
Remove the dotted lines.

⑤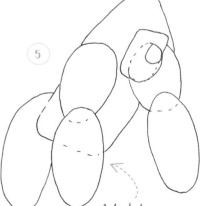

Add the lower arms and leg,
and round the front of the
face. Erase the dotted lines
from the middle of the forearms.

⑥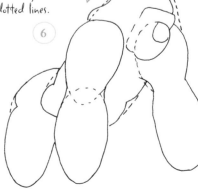

Smooth out the
limb shapes and
adjust the head
and body shape,
removing the
dotted lines.

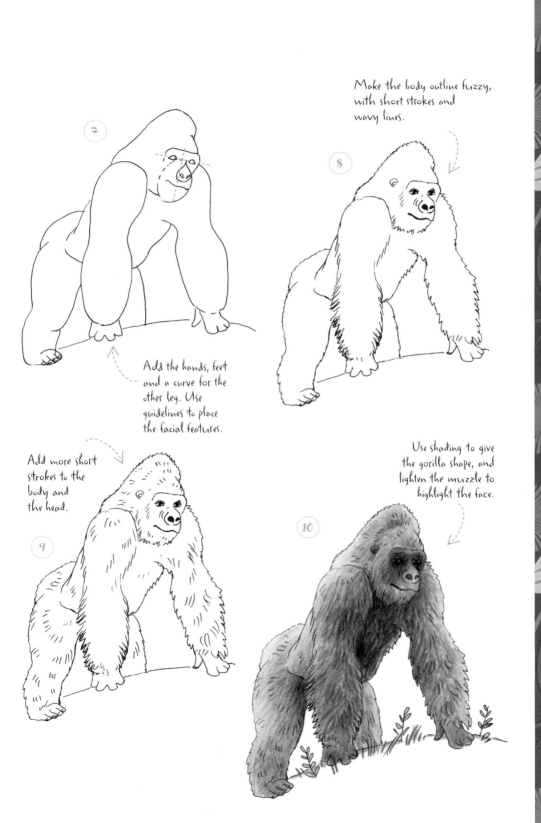

Make the body outline fuzzy, with short strokes and wavy lines.

7

8

Add the hands, feet and a curve for the other leg. Use guidelines to place the facial features.

29

Add more short strokes to the body and the head.

9

Use shading to give the gorilla shape, and lighten the muzzle to highlight the face.

10

Giant Panda

The giant panda is instantly recognisable, thanks to its distinctive black eyes, ears and legs. Pandas have furry bodies, so make sure that you make the lines fuzzy.

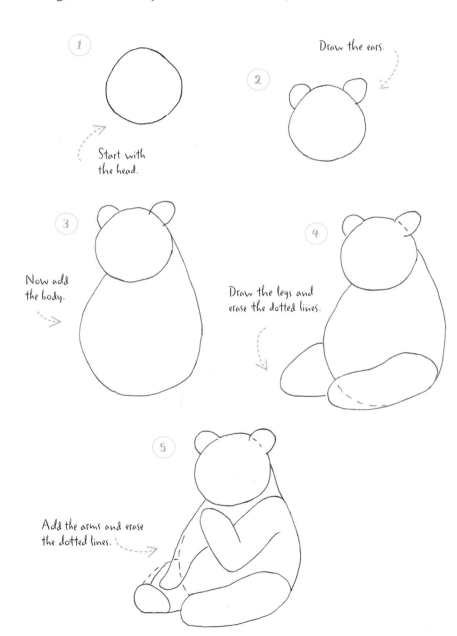

1

Start with the head.

Draw the ears.

2

3

Now add the body.

4

Draw the legs and erase the dotted lines.

5

Add the arms and erase the dotted lines.

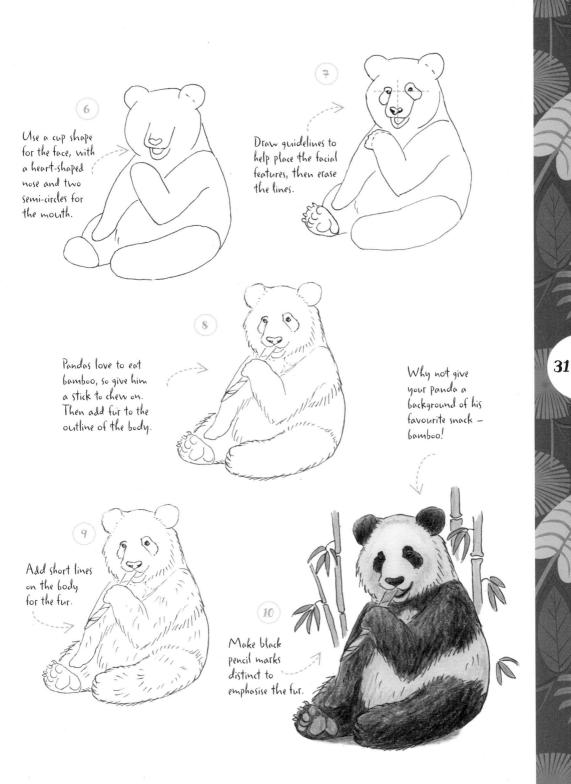

6

Use a cup shape for the face, with a heart-shaped nose and two semi-circles for the mouth.

7

Draw guidelines to help place the facial features, then erase the lines.

8

Pandas love to eat bamboo, so give him a stick to chew on. Then add fur to the outline of the body.

Why not give your panda a background of his favourite snack — bamboo!

31

9

Add short lines on the body for the fur.

10

Make black pencil marks distinct to emphasise the fur.

Antelope

Antelopes have a heart-shaped face and horns. Give them brown-, cream- and tan-coloured coats to match the dry, desert-like places that they live in.

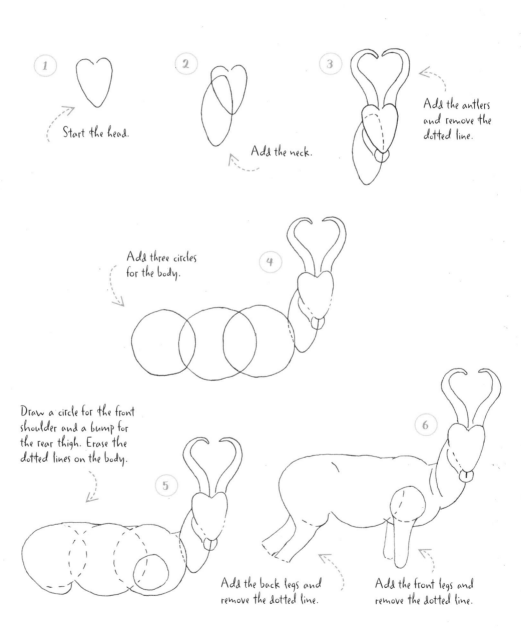

1 Start the head.

2 Add the neck.

3 Add the antlers and remove the dotted line.

Add three circles for the body.

4

Draw a circle for the front shoulder and a bump for the rear thigh. Erase the dotted lines on the body.

5

6

Add the back legs and remove the dotted line.

Add the front legs and remove the dotted line.

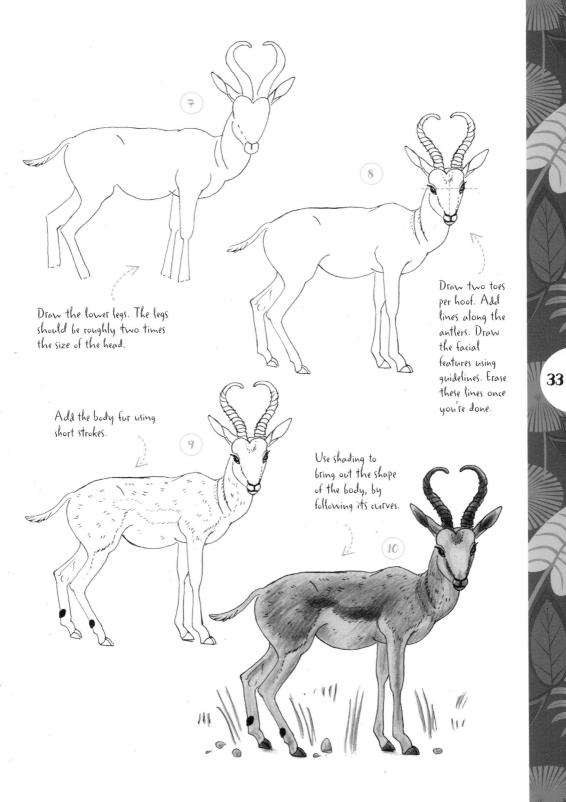

Draw the lower legs. The legs should be roughly two times the size of the head.

Draw two toes per hoof. Add lines along the antlers. Draw the facial features using guidelines. Erase these lines once you're done.

Add the body fur using short strokes.

Use shading to bring out the shape of the body, by following its curves.

33

Kangaroo

Kangaroos have long bodies and thin legs. Keep the tail and feet on the same line to show that they are both resting on the ground.

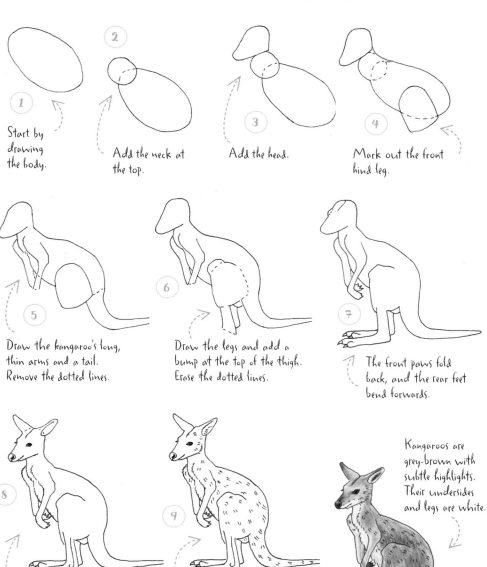

1 Start by drawing the body.

2 Add the neck at the top.

3 Add the head.

4 Mark out the front hind leg.

5 Draw the kangaroo's long, thin arms and a tail. Remove the dotted lines.

6 Draw the legs and add a bump at the top of the thigh. Erase the dotted lines.

7 The front paws fold back, and the rear feet bend forwards.

8 Add ears, eyes, a nose and fur to the front of the torso.

9 Use short strokes to create the rest of the fur.

10 Kangaroos are grey-brown with subtle highlights. Their undersides and legs are white.

Zebra

Zebras have distinctive black-and-white-striped coats. Their stripes are unique to each animal and come in different patterns. Make sure your stripes follow the curves of the zebra's body.

(1)

Start with the body.

(2)

The dashed spiral helps form the right shape for the leg.

Add the neck. Erase the dotted lines.

(3)

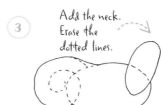

Add the face.

(4)

Add the ears and an eye. Draw a crooked line for the muzzle. Erase the dotted line.

(5)

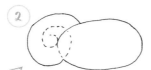

(6)

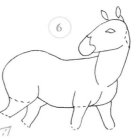

Start to add the legs. Remove the dotted lines on the head and back leg.

(7)

(8)

The back legs form a gentle 'L' shape, while the front legs are straight.

Add a fuzzy mane and tail, and hooves. Erase the dotted line from the leg.

The solid black of the muzzle will draw attention to the zebra's face.

(9)

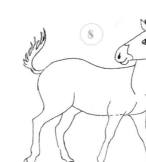

Add stripes that follow the curves of the body.

(10)

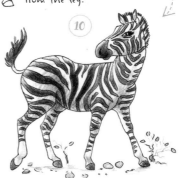

Tiger

Tigers have beautiful, detailed markings, so take your time
when adding them in the final steps.

①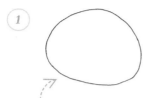

Start with the head.

②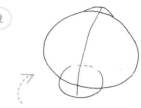

Add the muzzle and a slight bump at
the top of the head. Draw a line through
the face to help you line up the body in
later steps.

③

Add a teardrop shape
for the front of the
torso and a curve below
the muzzle for the
lower jaw.

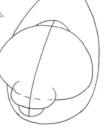

④

Continue the line
through the body
and add on a
fingertip shape for
the rear torso.

⑤

Add the front legs and a curve for
the back leg. Remove the dotted
lines on the legs.

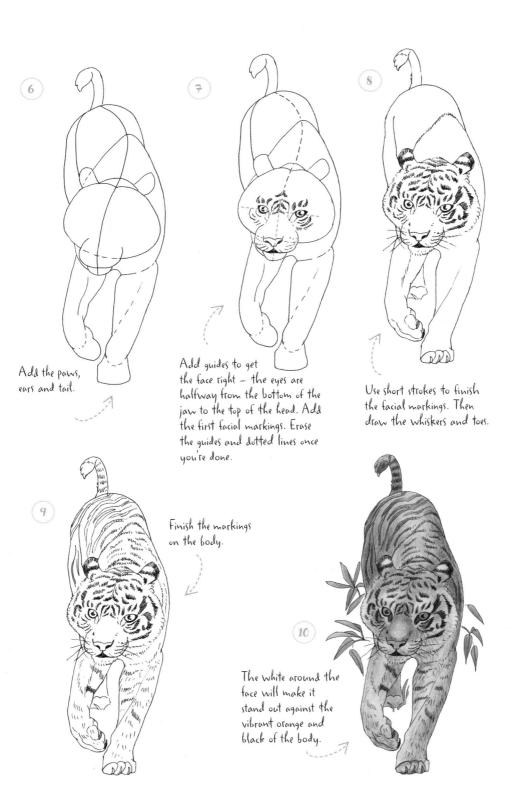

6

Add the paws, ears and tail.

7

Add guides to get the face right – the eyes are halfway from the bottom of the jaw to the top of the head. Add the first facial markings. Erase the guides and dotted lines once you're done.

8

Use short strokes to finish the facial markings. Then draw the whiskers and toes.

9

Finish the markings on the body.

10

The white around the face will make it stand out against the vibrant orange and black of the body.

Chimpanzee

This cute primate has many human-like features, so take your time to get the face, hands and feet right.

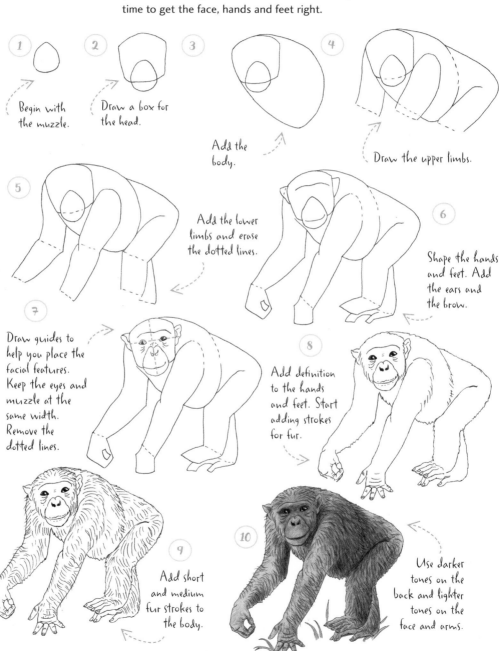

1 Begin with the muzzle.

2 Draw a box for the head.

3 Add the body.

4 Draw the upper limbs.

5 Add the lower limbs and erase the dotted lines.

6 Shape the hands and feet. Add the ears and the brow.

7 Draw guides to help you place the facial features. Keep the eyes and muzzle at the same width. Remove the dotted lines.

8 Add definition to the hands and feet. Start adding strokes for fur.

9 Add short and medium fur strokes to the body.

10 Use darker tones on the back and lighter tones on the face and arms.

38

Koala

Koalas are fun to draw because of the oversized proportions of their face, which make them one of the cutest animals in Australia!

(1) Start with the head.

(2) Add the nose and remove the dotted line.

(3) Add the ears and draw a short line for the mouth. Erase the dotted line in the ear.

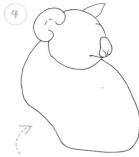

(4) Add the body.

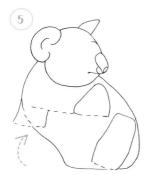

(5) Add the upper limbs. Draw a guideline to help line them up, then erase the line through the chest.

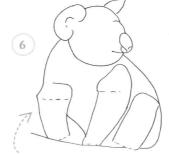

(6) Draw the lower front legs. Erase the remaining guides.

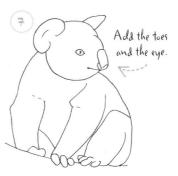

(7) Add the toes and the eye.

Use pink to highlight the ear, under the mouth and around the eye. This will draw attention to the face.

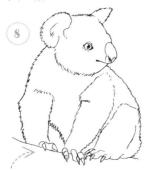

(8) Add claws to the toes and short strokes on the body for fur.

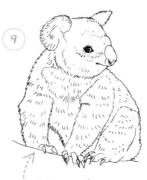

(9) Add more short strokes to the body and head.

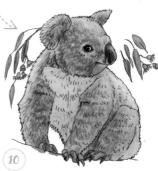

(10)

Platypus

Platypuses are designed to speed through the water.
Make sure that yours is streamlined and curvy.

1 Start with the head.

2 Add the body.

3 Draw in the bill and add a curve under the head for the chest. Erase the dotted lines.

4 Add a tail and erase the dotted lines.

5 Add the upper legs and erase any guides.

6 Add the paws.

7 Detail the bill and add a small eye.

8 Finish the paws and add claws.

9 Add sets of three strokes to the body for the fur.

10 When colouring, make sure that you give the platypus a pale underside.

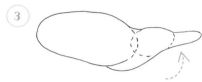
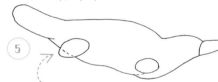
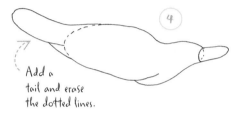
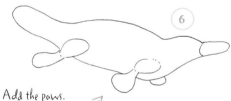
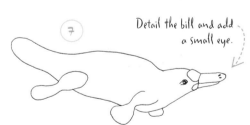
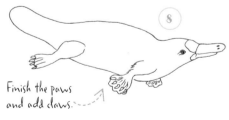
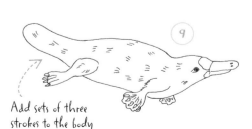

Dung Beetle

Dung beetles are easy to draw because their shell makes a shiny semi-circle.
Make their legs hairy and spiky, with tiny claw feet.

1 Start with the body.

2 Divide the semi-circle into two with an arc.

3 Add the head and refine the body segments. Remove the dotted lines.

4 Add striped markings to the lower abdomen, stripes along the edge of the shell, and circular highlights.

5 Add the legs.

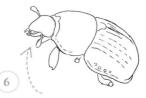

6 Add jaws and an antenna.

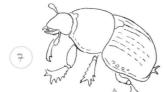

7 The lower leg joints are serrated like saw blades.

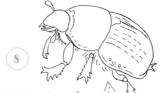

8 Add fur along the bottom of the body.

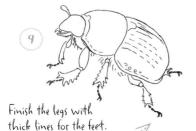

9 Finish the legs with thick lines for the feet.

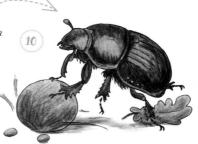

10 Dung beetles are black, but also quite shiny. Vary the tones on the abdomen so that yours appears to reflect the light.

41

Anteater

Formed by a collection of cone shapes, anteaters are easy to draw.
Start with the long snout, which is used for eating ants and termites.

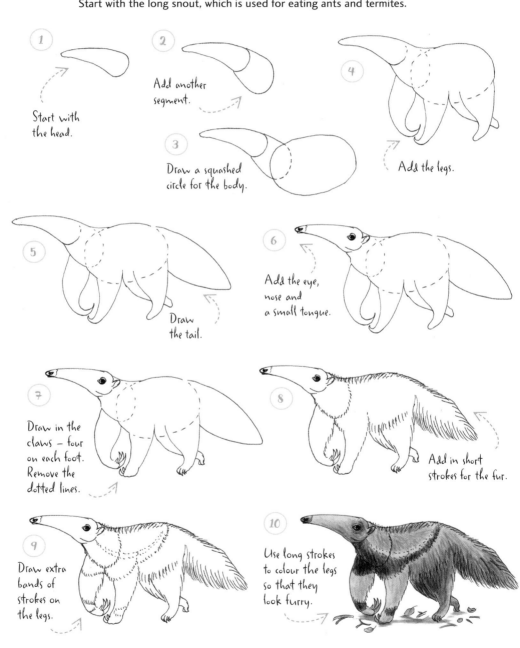

① Start with the head.

② Add another segment.

③ Draw a squashed circle for the body.

④ Add the legs.

⑤ Draw the tail.

⑥ Add the eye, nose and a small tongue.

⑦ Draw in the claws — four on each foot. Remove the dotted lines.

⑧ Add in short strokes for the fur.

⑨ Draw extra bands of strokes on the legs.

⑩ Use long strokes to colour the legs so that they look furry.

Sloth

As sloths spend so much time in trees, the branch is an important part of this scene.
Draw the arms before adding curves for the branch, so that they match up.

① Start with the body.

② Add the front arm.

③ Draw the head and chest. Erase the dotted lines.

④ Add the other arm and the back leg.

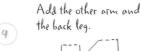

⑤ Complete the limbs, then add a branch. Remove the dotted lines.

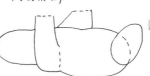

⑥ Draw the claws and a tail. Erase the dotted line on the leg.

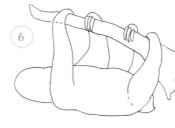

43

⑦ Use guidelines to place the facial features, the erase the guides.

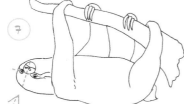

⑧ Add fur.

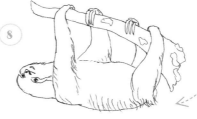

⑨ Draw long curved strokes over the rest of the body.

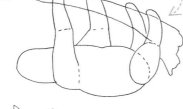

⑩ Follow the strokes when colouring, for a more natural appearance.

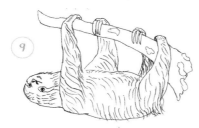
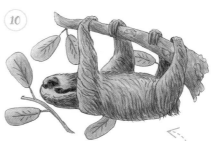

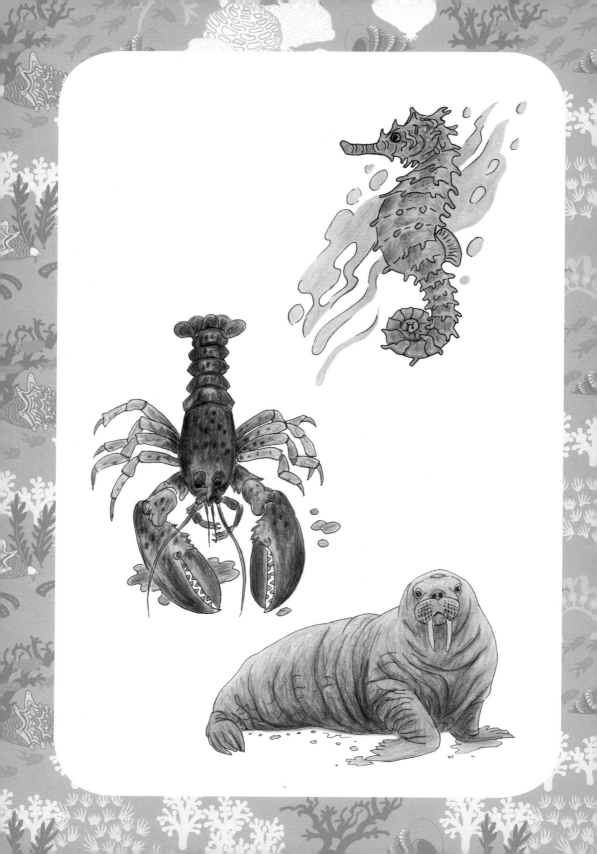

Aquatic Animals

Blue Whale

Although they are very large, blue whales
have a simple, streamlined shape.

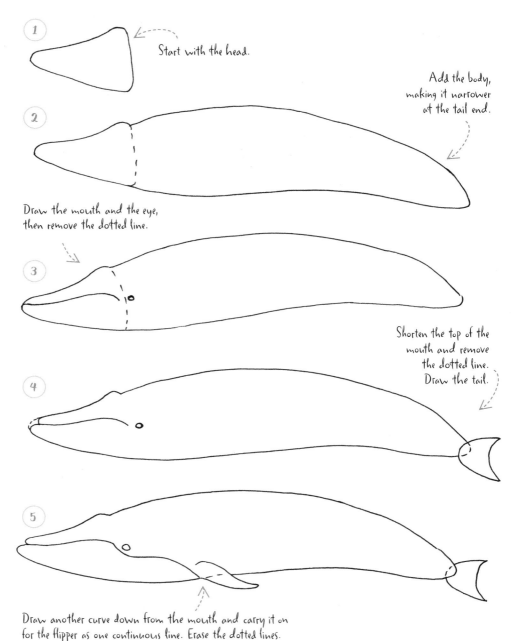

1 Start with the head.

Add the body,
making it narrower
at the tail end.

2

Draw the mouth and the eye,
then remove the dotted line.

3

Shorten the top of the
mouth and remove
the dotted line.
Draw the tail.

4

5

Draw another curve down from the mouth and carry it on
for the flipper as one continuous line. Erase the dotted lines.

46

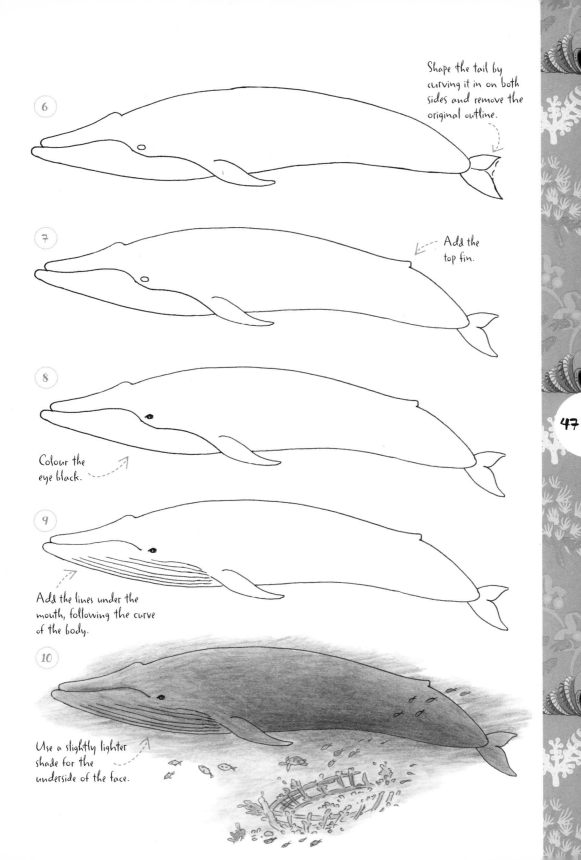

6

Shape the tail by curving it in on both sides and remove the original outline.

7

Add the top fin.

8

Colour the eye black.

9

Add the lines under the mouth, following the curve of the body.

10

Use a slightly lighter shade for the underside of the face.

47

Common Seal

Seals are curved, streamlined animals. Pay attention to the shadows around the soft folds of the skin.

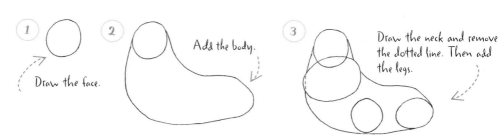

① Draw the face.

② Add the body.

③ Draw the neck and remove the dotted line. Then add the legs.

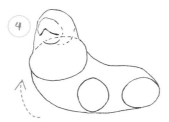

④ Draw the muzzle and add a line for the mouth. Erase the dotted line on the neck.

⑤ Add an 'S' shape above the front leg and a bump for the left shoulder. Then erase the dotted lines.

⑥ Add the front legs and add detail to the back.

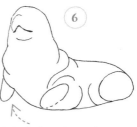

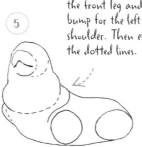

⑦ Add in four flippers, with wavy lines for the toes. Remove any guides.

Draw guidelines to help you place the facial features. Erase these lines once you're done.

⑧

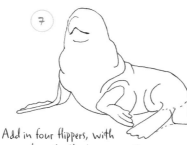

⑨ Add short lines for the fur.

⑩ Add short, vertical lines with different coloured pencils to make the seal appear furry.

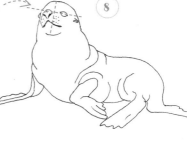

Goldfish

The hardest part of the goldfish is getting the scales to line up and shrink towards the tail. You might want to practise drawing the pattern by itself first.

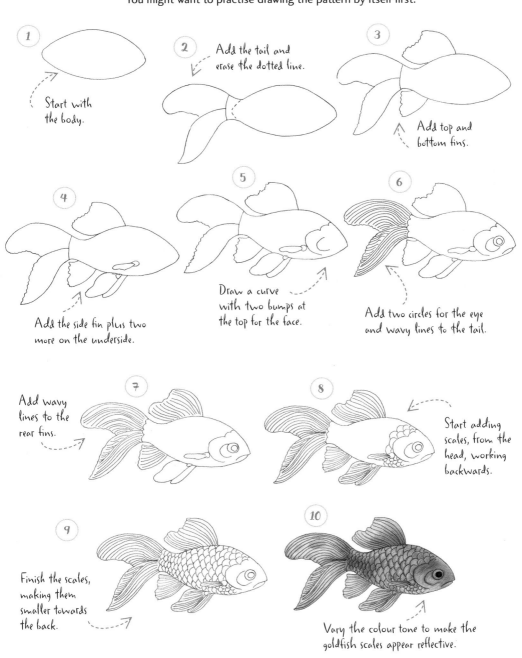

1 Start with the body.

2 Add the tail and erase the dotted line.

3 Add top and bottom fins.

4 Add the side fin plus two more on the underside.

5 Draw a curve with two bumps at the top for the face.

6 Add two circles for the eye and wavy lines to the tail.

7 Add wavy lines to the rear fins.

8 Start adding scales, from the head, working backwards.

9 Finish the scales, making them smaller towards the back.

10 Vary the colour tone to make the goldfish scales appear reflective.

Great White Shark

Sharks consist mostly of triangular shapes – from their
pointy noses to their angular tails.

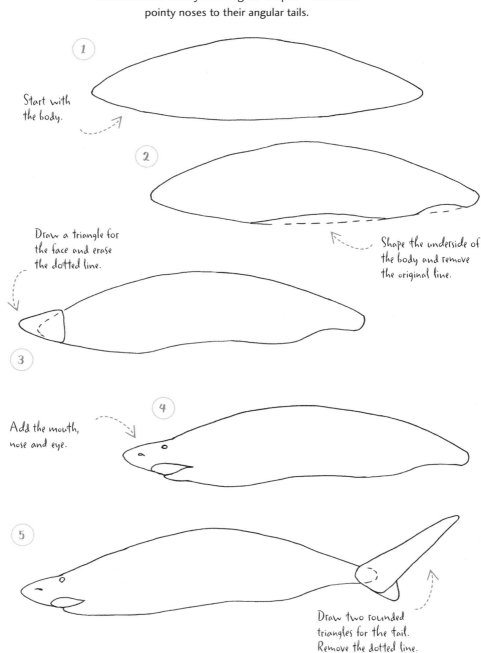

1

Start with
the body.

2

Draw a triangle for
the face and erase
the dotted line.

Shape the underside of
the body and remove
the original line.

3

Add the mouth,
nose and eye.

4

5

Draw two rounded
triangles for the tail.
Remove the dotted line.

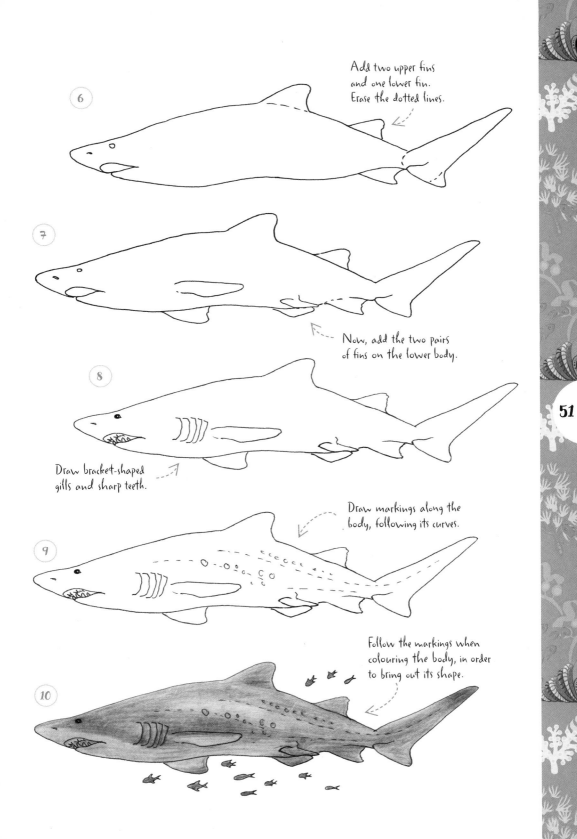

6 Add two upper fins
and one lower fin.
Erase the dotted lines.

7 Now, add the two pairs
of fins on the lower body.

8 Draw bracket-shaped
gills and sharp teeth.

51

9 Draw markings along the
body, following its curves.

10 Follow the markings when
colouring the body, in order
to bring out its shape.

Lobster

Lobsters are symmetrical, which makes them much easier to draw, although they do have many separate body parts.

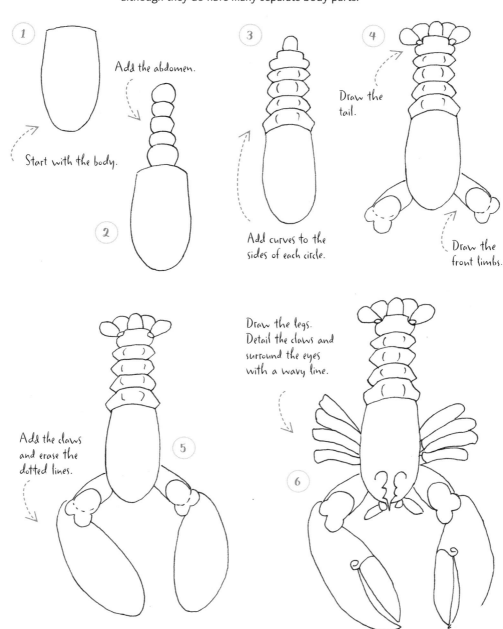

① Start with the body.

Add the abdomen.

②

③ Add curves to the sides of each circle.

④ Draw the tail.

Draw the front limbs.

⑤ Add the claws and erase the dotted lines.

Draw the legs. Detail the claws and surround the eyes with a wavy line.

⑥

52

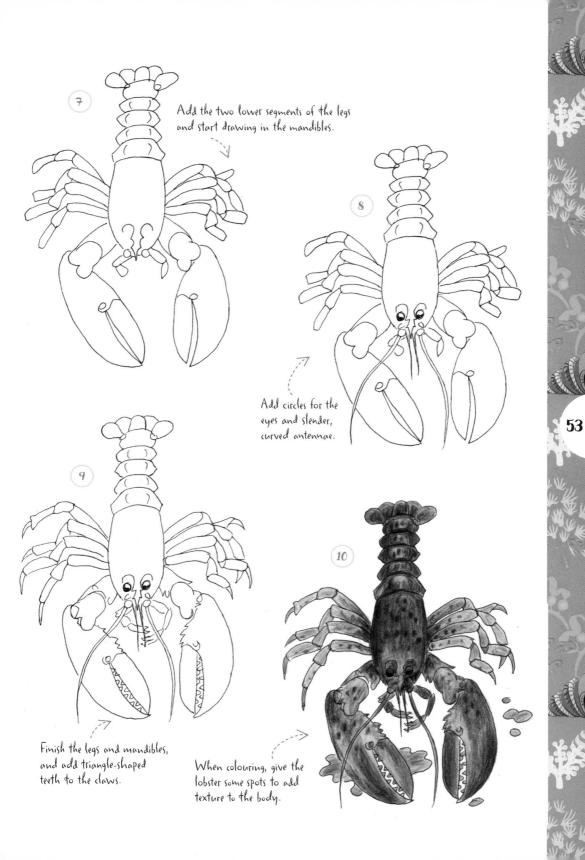

7

Add the two lower segments of the legs and start drawing in the mandibles.

8

Add circles for the eyes and slender, curved antennae.

9

10

Finish the legs and mandibles, and add triangle-shaped teeth to the claws.

When colouring, give the lobster some spots to add texture to the body.

Sea Turtle

Turtles have a bony shell that develops from the ribs and acts as a shield for their soft bodies. The shell pattern looks complex to draw, but it is actually straightforward.

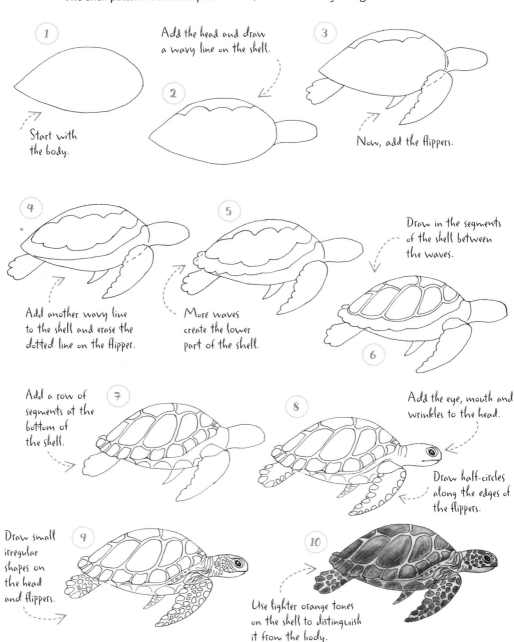

① Start with the body.

Add the head and draw a wavy line on the shell.

②

③ Now, add the flippers.

④ Add another wavy line to the shell and erase the dotted line on the flipper.

⑤ More waves create the lower part of the shell.

Draw in the segments of the shell between the waves.

⑥

Add a row of segments at the bottom of the shell.

⑦

⑧ Add the eye, mouth and wrinkles to the head.

Draw half-circles along the edges of the flippers.

Draw small irregular shapes on the head and flippers.

⑨

⑩ Use lighter orange tones on the shell to distinguish it from the body.

Crab

Crabs have hard shells and they are symmetrical. Make sure to give them lots of spikes and serrations, as they need these to protect themselves.

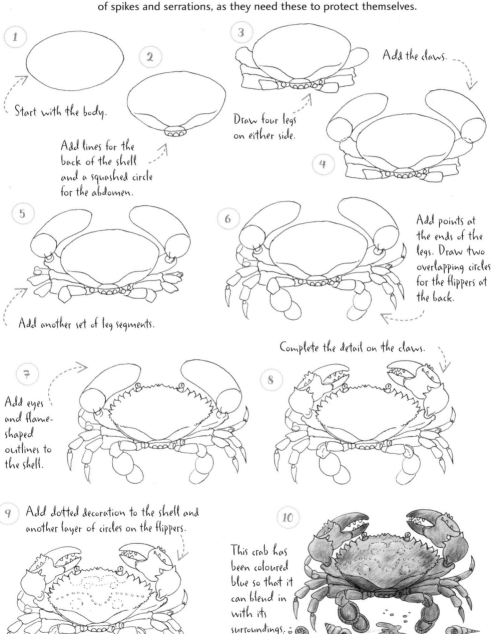

1 Start with the body.

2 Add lines for the back of the shell and a squashed circle for the abdomen.

3 Draw four legs on either side.

Add the claws.

4

5 Add another set of leg segments.

6 Add points at the ends of the legs. Draw two overlapping circles for the flippers at the back.

Complete the detail on the claws.

7 Add eyes and flame-shaped outlines to the shell.

8

9 Add dotted decoration to the shell and another layer of circles on the flippers.

10 This crab has been coloured blue so that it can blend in with its surroundings.

Orca

Orca are part of the oceanic dolphin family, making them sleek and shiny in water. Pay special attention to the highlights on the body.

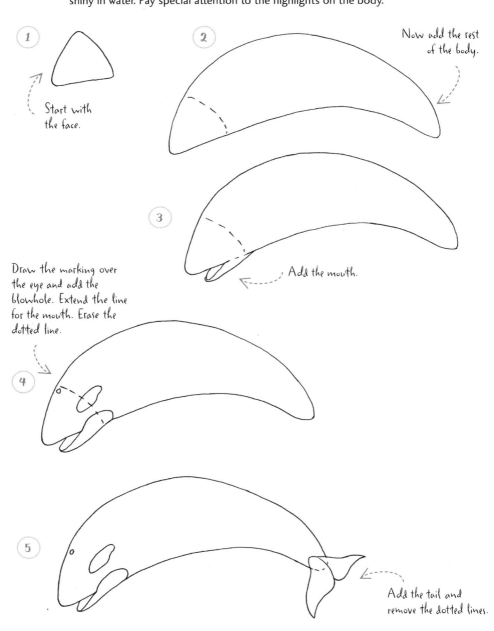

1 Start with the face.

2 Now add the rest of the body.

3 Add the mouth.

Draw the marking over the eye and add the blowhole. Extend the line for the mouth. Erase the dotted line.

4

5 Add the tail and remove the dotted lines.

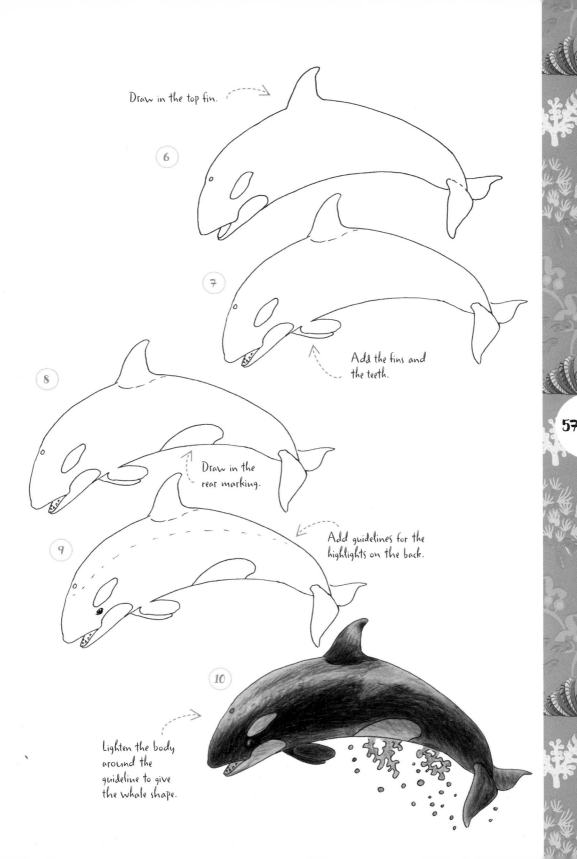

Draw in the top fin.

6

7

Add the fins and
the teeth.

8

Draw in the
rear marking.

Add guidelines for the
highlights on the back.

9

10

Lighten the body
around the
guideline to give
the whale shape.

Seahorse

Seahorses are small, marine fish. Their head and neck look similar to those of a horse, as does their upright position, bony armour and curled tail.

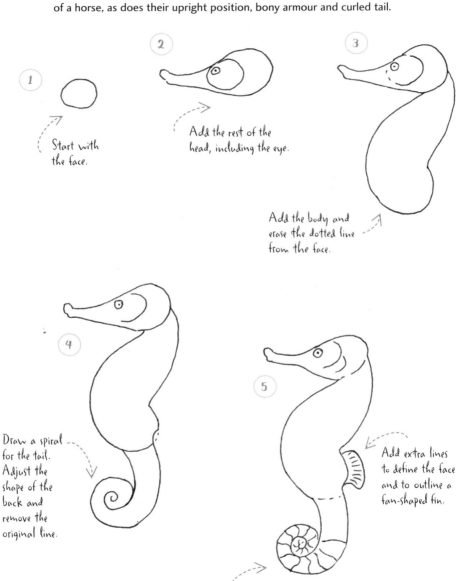

1

Start with the face.

2

Add the rest of the head, including the eye.

3

Add the body and erase the dotted line from the face.

4

Draw a spiral for the tail. Adjust the shape of the back and remove the original line.

5

Add extra lines to define the face and to outline a fan-shaped fin.

Add segments to the end of the tail and erase the dotted line at the top.

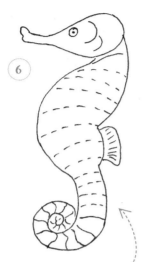

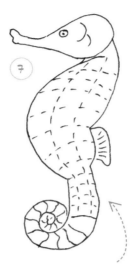

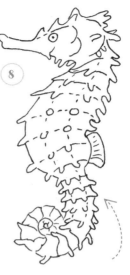

6 Use dashed curves across the body, making them narrower at the top and bottom of the seahorse.

7 Add two vertical dashed curves, following the shape of the body.

8 Add rows of four soft spikes all the way down the body, following the intersections of your dashes. Then add soft spikes to the outline of the head.

Add short curves to the face.

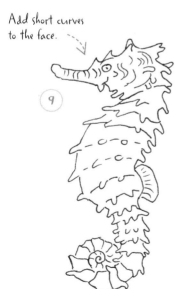

9

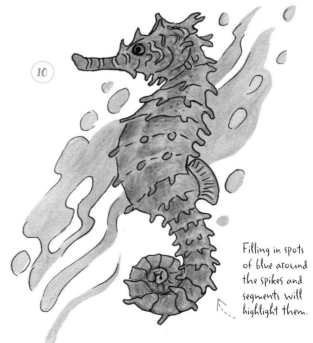

10

Filling in spots of blue around the spikes and segments will highlight them.

Penguin

Penguins are easy to draw, but it is important to use shading to give them form and make them look realistic.

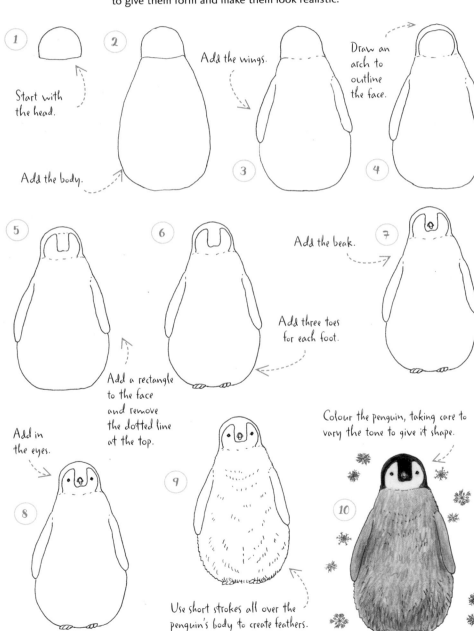

① Start with the head.

Add the body.

② Add the wings.

③

④ Draw an arch to outline the face.

⑤

⑥ Add a rectangle to the face and remove the dotted line at the top.

⑦ Add the beak.

Add three toes for each foot.

⑧ Add in the eyes.

⑨ Use short strokes all over the penguin's body to create feathers.

⑩ Colour the penguin, taking care to vary the tone to give it shape.

Octopus

The octopus has eight arms that trail behind it as it swims. There are few straight lines when drawing an octopus, so it's rewarding to draw one well!

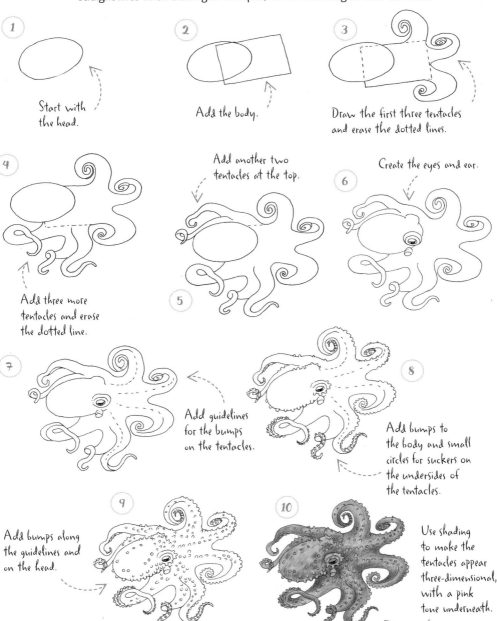

1 Start with the head.

2 Add the body.

3 Draw the first three tentacles and erase the dotted lines.

4 Add three more tentacles and erase the dotted line.

5 Add another two tentacles at the top.

6 Create the eyes and ear.

7 Add guidelines for the bumps on the tentacles.

8 Add bumps to the body and small circles for suckers on the undersides of the tentacles.

9 Add bumps along the guidelines and on the head.

10 Use shading to make the tentacles appear three-dimensional, with a pink tone underneath.

Polar Bear

These marine mammals have large, shaggy bodies, designed for the cold climates they live in. Make sure to keep the limbs of your polar bear wide to reflect its powerful stride!

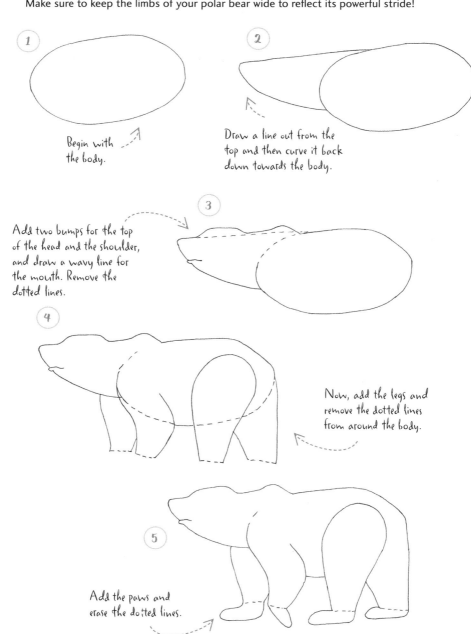

1 Begin with the body.

2 Draw a line out from the top and then curve it back down towards the body.

3 Add two bumps for the top of the head and the shoulder, and draw a wavy line for the mouth. Remove the dotted lines.

4 Now, add the legs and remove the dotted lines from around the body.

5 Add the paws and erase the dotted lines.

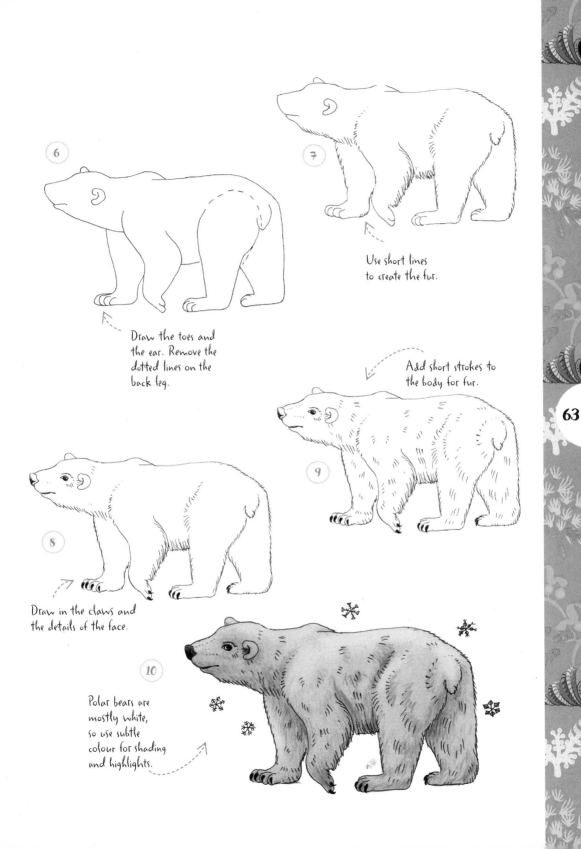

6

7 Use short lines
to create the fur.

Draw the toes and
the ear. Remove the
dotted lines on the
back leg.

Add short strokes to
the body for fur.

9

8

Draw in the claws and
the details of the face.

10

Polar bears are
mostly white,
so use subtle
colour for shading
and highlights.

63

Blue Tang

Fish are easy to draw because they have basic body shapes. The only complex parts are adding the frilly fins and getting the colouring right.

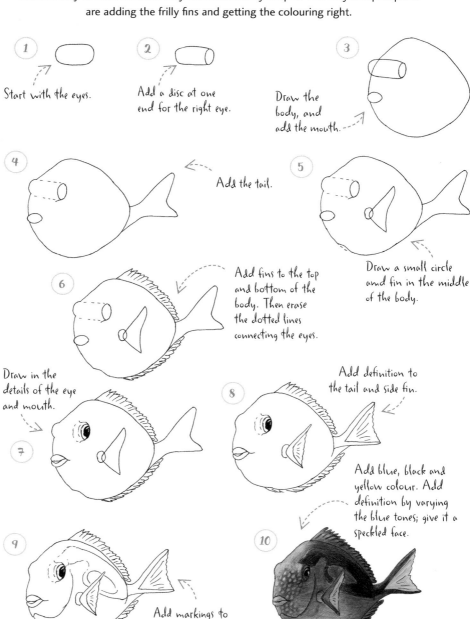

1. Start with the eyes.

2. Add a disc at one end for the right eye.

3. Draw the body, and add the mouth.

Add the tail.

4.

5. Draw a small circle and fin in the middle of the body.

6. Add fins to the top and bottom of the body. Then erase the dotted lines connecting the eyes.

7. Draw in the details of the eye and mouth.

8. Add definition to the tail and side fin.

Add blue, black and yellow colour. Add definition by varying the blue tones; give it a speckled face.

9. Add markings to the fish's body.

10.

Jellyfish

Jellyfish are known for their umbrella-shaped bodies and long tentacles. Once you've mastered the steps below try varying the shape of the body and tentacles to show the jellyfish in motion.

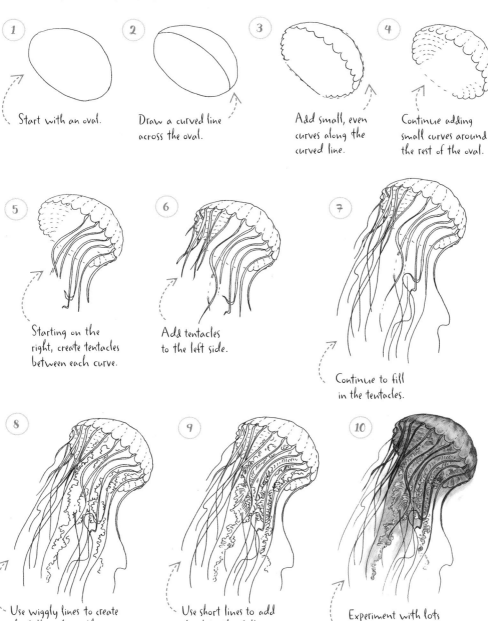

1 Start with an oval.

2 Draw a curved line across the oval.

3 Add small, even curves along the curved line.

4 Continue adding small curves around the rest of the oval.

5 Starting on the right, create tentacles between each curve.

6 Add tentacles to the left side.

7 Continue to fill in the tentacles.

8 Use wiggly lines to create the frill underneath the jellyfish.

9 Use short lines to add detail to the frill.

10 Experiment with lots of different colours.

Dolphin

Dolphins are sleek with rounded bodies and curves,
which help them to move quickly through water.

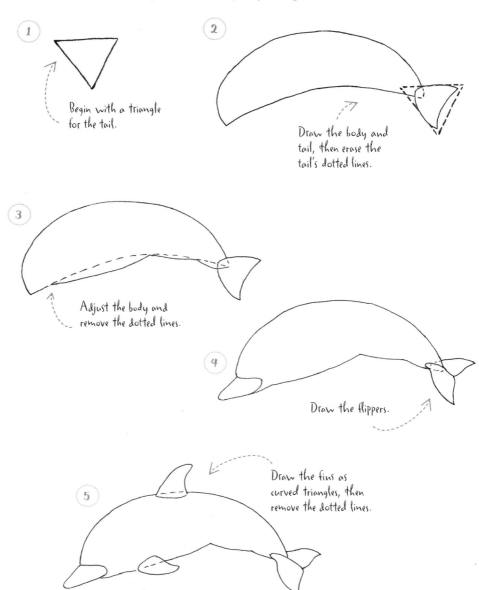

1 Begin with a triangle
for the tail.

2 Draw the body and
tail, then erase the
tail's dotted lines.

3 Adjust the body and
remove the dotted lines.

4 Draw the flippers.

5 Draw the fins as
curved triangles, then
remove the dotted lines.

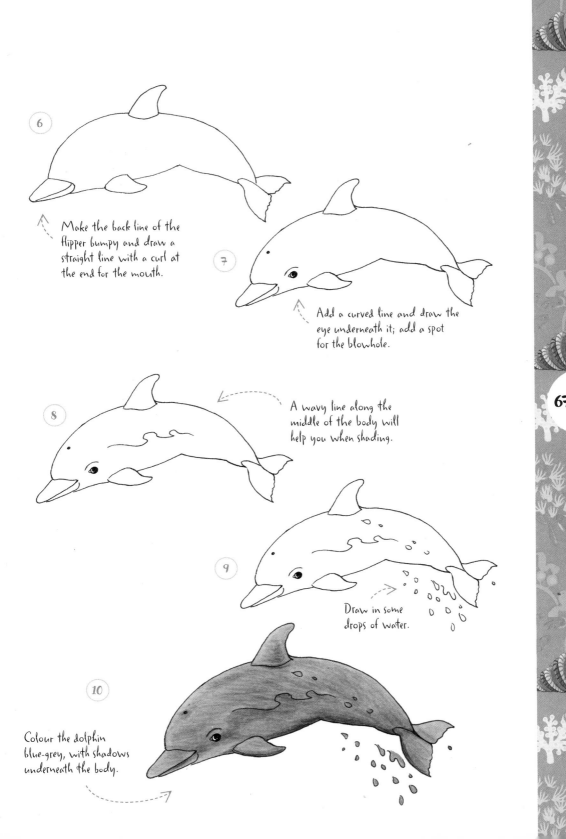

6

Make the back line of the
flipper bumpy and draw a
straight line with a curl at
the end for the mouth.

7

Add a curved line and draw the
eye underneath it; add a spot
for the blowhole.

8

A wavy line along the
middle of the body will
help you when shading.

9

Draw in some
drops of water.

10

Colour the dolphin
blue-grey, with shadows
underneath the body.

Walrus

Walruses have shapeless bodies. Make sure that you add detail to the folds of their skin in order to give them realistic form.

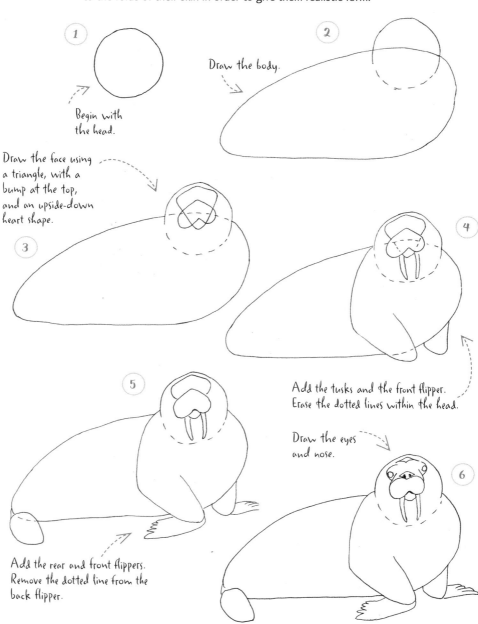

1

Begin with the head.

2

Draw the body.

Draw the face using a triangle, with a bump at the top, and an upside-down heart shape.

3

4

Add the tusks and the front flipper. Erase the dotted lines within the head.

Draw the eyes and nose.

5

Add the rear and front flippers. Remove the dotted line from the back flipper.

6

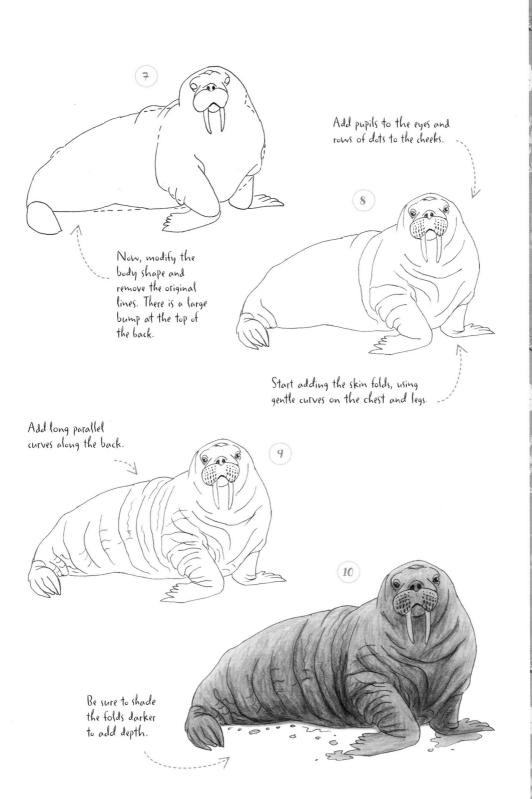

⑦

Now, modify the body shape and remove the original lines. There is a large bump at the top of the back.

Add pupils to the eyes and rows of dots to the cheeks.

⑧

Start adding the skin folds, using gentle curves on the chest and legs.

Add long parallel curves along the back.

⑨

⑩

Be sure to shade the folds darker to add depth.

Hammerhead Shark

Hammerhead sharks have a simple but distinctive shape.
Pay attention to the rough outline of the front of the face.

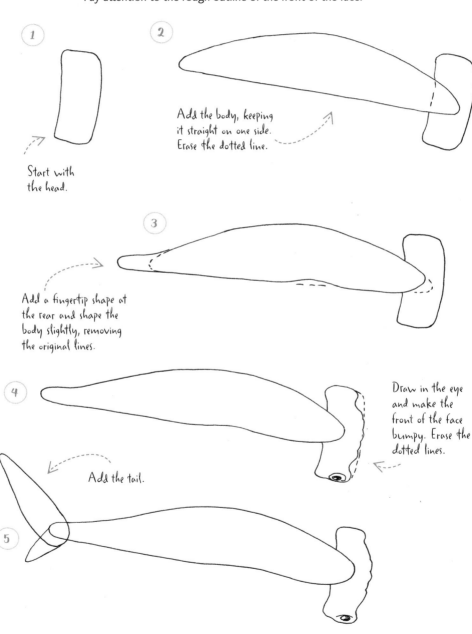

①

Start with
the head.

②

Add the body, keeping
it straight on one side.
Erase the dotted line.

③

Add a fingertip shape at
the rear and shape the
body slightly, removing
the original lines.

④

Draw in the eye
and make the
front of the face
bumpy. Erase the
dotted lines.

Add the tail.

⑤

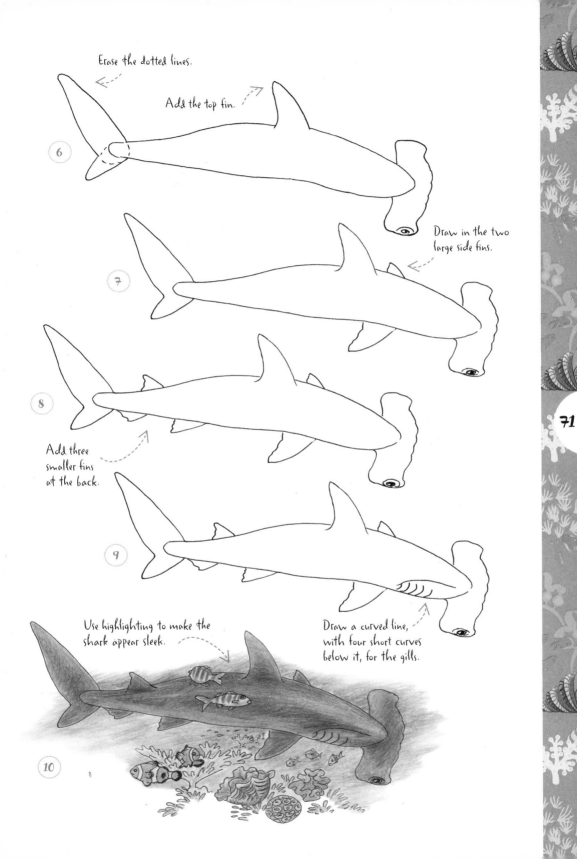

Erase the dotted lines.

Add the top fin.

6

Draw in the two large side fins.

7

8

Add three smaller fins at the back.

9

Use highlighting to make the shark appear sleek.

Draw a curved line, with four short curves below it, for the gills.

10

71

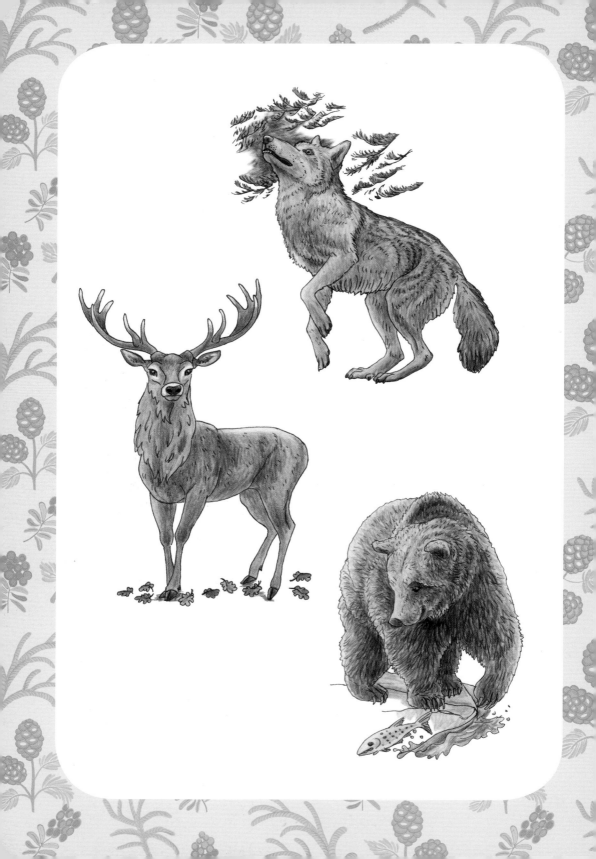

Woodland Animals

Fox

Foxes have furry bodies and exceptionally bushy tails.
Use long strokes on the tail to give it volume.

1

Start with a stretched oval
with straight sides.

2

Add a 'C' shape
to the left side
of the oval.

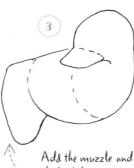

3

Add the muzzle and
the back leg.

Add ears and the tail.
Erase the dotted line
in the ear.

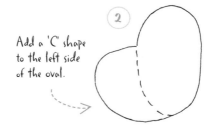

4

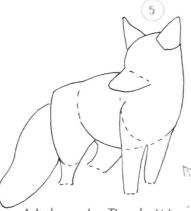

5

Add the upper legs. These should be
one head in length. Erase the dotted
lines at the front of the body.

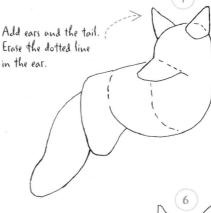

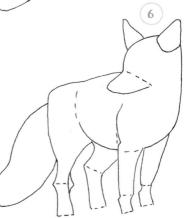

6

Draw the lower legs. These should
be ½ a head in length. Remove the
dotted lines.

Add further detail
to the face.

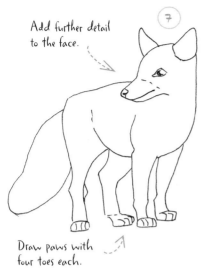

Draw paws with
four toes each.

Use long strokes to create
the bushy tail.

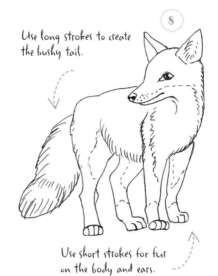

Use short strokes for fur
on the body and ears.
These strokes should
outline the fox's bib.

Add some
more short
strokes to
the body.

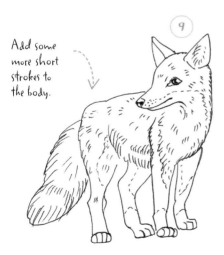

Foxes are orange, with
white fur on the legs, the
tip of the tail, and the
front bib.

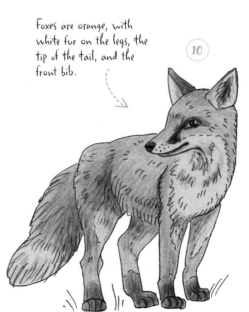

Snail

Snails are defined by their beautiful spiral shells, so practise drawing precise curves to make your snail shell look really good.

①

Start with a slightly squashed circle.

②

Draw a spiral out from the circle and add a gentle curve inwards.

③

Add another curve at the bottom of the shell, and then a dashed curve to the right of the inner spiral.

④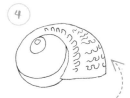

Add 'U' shapes along the dashed curve and the front part of the shell.

⑤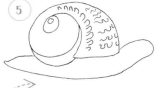

Draw in the snail's body.

Draw in the segments of the shell on the inner spiral, making them closer together towards the centre.

⑥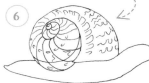

Add two sets of antennae. Shape the body and remove the original lines.

⑦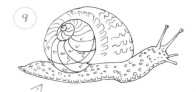

⑧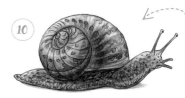

Follow these with tiny 'W' shapes along the bottom of the body.

⑨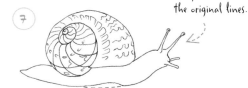

⑩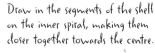

Note how the grey of the snail's body contrasts with the warm colours of the shell.

Draw in some 'C' shapes on the body to add texture.

Bumblebee

Bumblebees have a simple, round body that is covered in soft hair, or 'pile', which gives them a deceptively soft and fuzzy look! Take care when colouring to make the wings appear see-through.

1 Draw a circle for the body.

2 Add two more circles for the front stripe and head.

3 Add the wings. Erase the dotted line from the face.

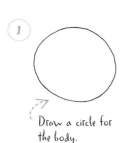

4 Add the eyes, with circles for reflections.

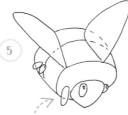

5 Start adding the first segments of the legs and a curve for the body's stripes.

6 Remove the dotted lines from the wings and draw the wing segments. Make the stripes into dotted lines and add the antennae.

7 Finish the wing segments with small, uneven shapes.

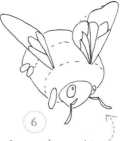

8 Finish the legs and fill in the eyes.

9 Add fur to the body using short strokes, mostly along the stripes. Finish the legs.

10 Make sure that the eyes stand out against the dark face – don't make it completely black.

Deer

A deer's head and torso is made up of simple shapes.
Make sure that you keep the antlers symmetrical.

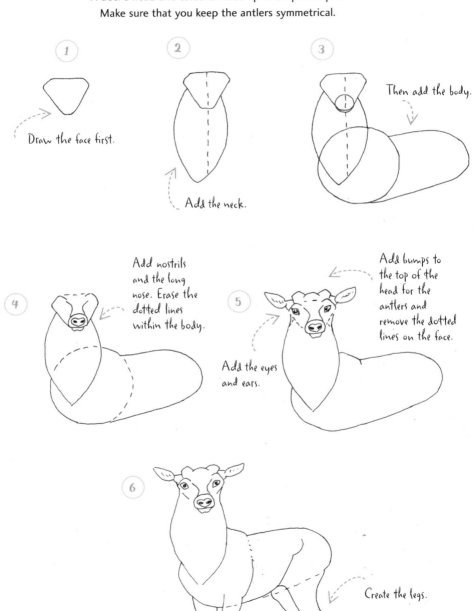

1

Draw the face first.

2

Add the neck.

3

Then add the body.

4

Add nostrils and the long nose. Erase the dotted lines within the body.

5

Add the eyes and ears.

Add bumps to the top of the head for the antlers and remove the dotted lines on the face.

6

Create the legs.

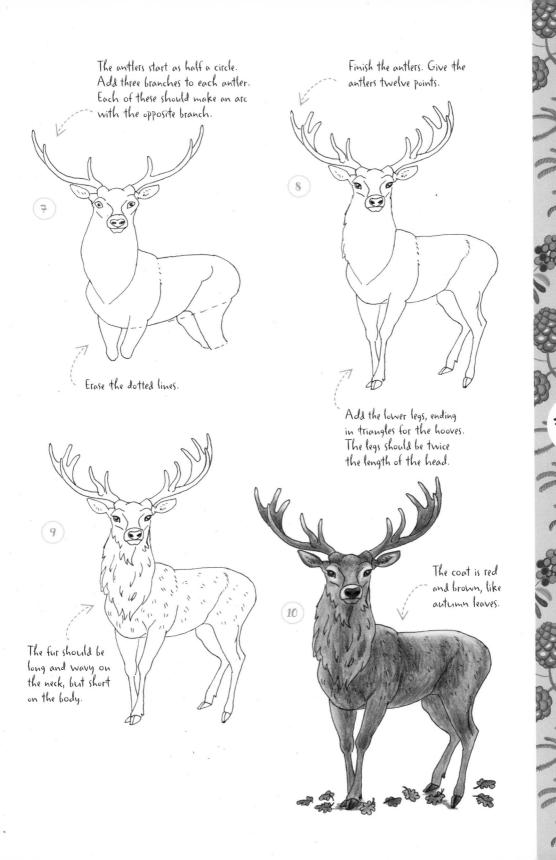

The antlers start as half a circle. Add three branches to each antler. Each of these should make an arc with the opposite branch.

7

Erase the dotted lines.

Finish the antlers. Give the antlers twelve points.

8

Add the lower legs, ending in triangles for the hooves. The legs should be twice the length of the head.

79

9

The fur should be long and wavy on the neck, but short on the body.

10

The coat is red and brown, like autumn leaves.

Frog

Frogs are fun to draw because of their protruding eyes and spindly feet; make sure you use curved lines when drawing yours.

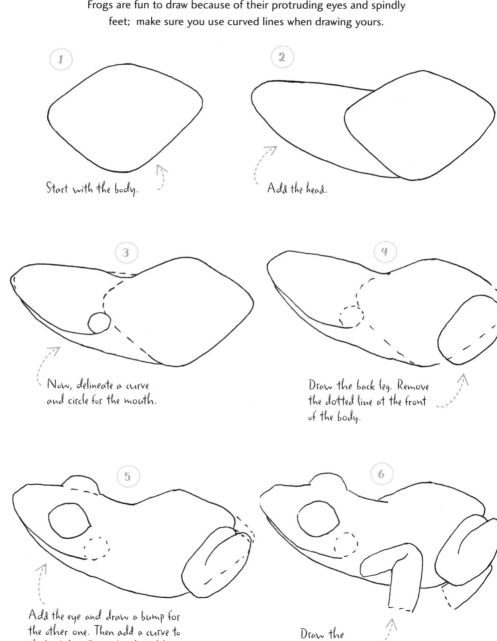

1

Start with the body.

2

Add the head.

3

Now, delineate a curve and circle for the mouth.

4

Draw the back leg. Remove the dotted line at the front of the body.

5

Add the eye and draw a bump for the other one. Then add a curve to the back leg. Erase the dotted line from the eye and leg.

6

Draw the front leg.

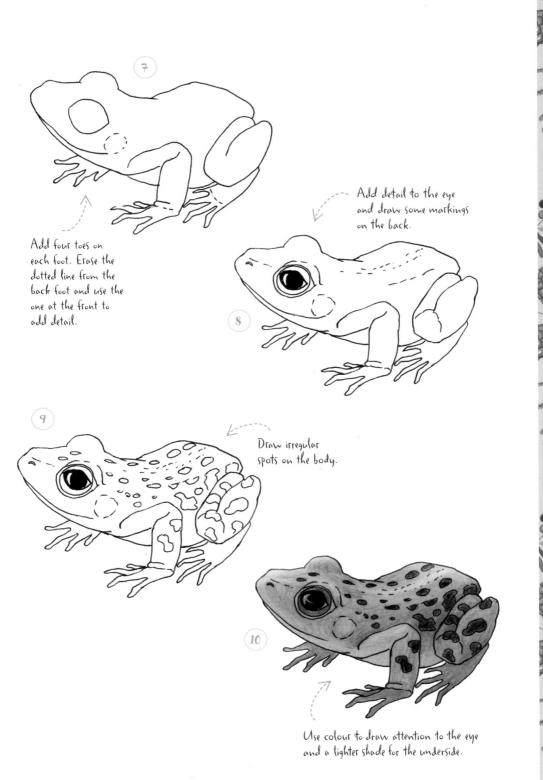

Add four toes on each foot. Erase the dotted line from the back foot and use the one at the front to add detail.

Add detail to the eye and draw some markings on the back.

Draw irregular spots on the body.

Use colour to draw attention to the eye and a lighter shade for the underside.

81

Wolf

Two simple circles form the basic shape of the wolf's body for this drawing.
This pose may seem challenging, but the initial shapes will help guide you.

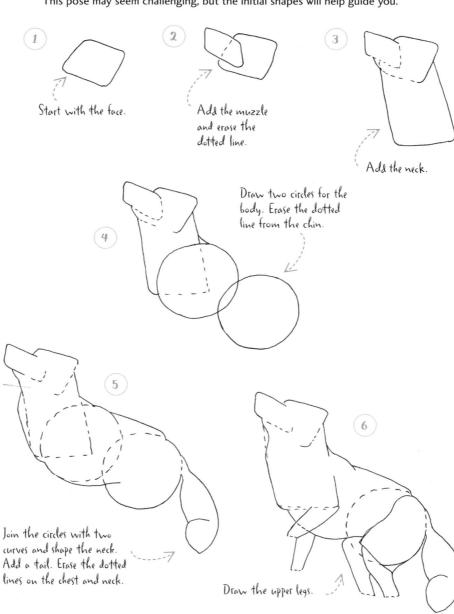

1 Start with the face.

2 Add the muzzle and erase the dotted line.

3 Add the neck.

Draw two circles for the body. Erase the dotted line from the chin.

4

5 Join the circles with two curves and shape the neck. Add a tail. Erase the dotted lines on the chest and neck.

6 Draw the upper legs.

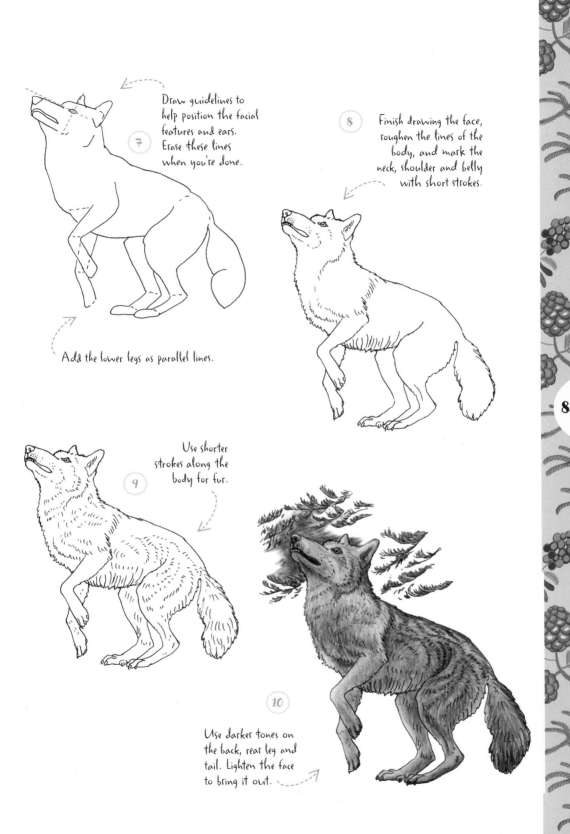

Draw guidelines to help position the facial features and ears. Erase these lines when you're done.

7

Add the lower legs as parallel lines.

8

Finish drawing the face, roughen the lines of the body, and mark the neck, shoulder and belly with short strokes.

83

Use shorter strokes along the body for fur.

9

10

Use darker tones on the back, rear leg and tail. Lighten the face to bring it out.

Raccoon

Raccoons have very dense fur to keep them warm and insulated against the cold. Use long strokes when colouring yours to give its fur a sense of depth.

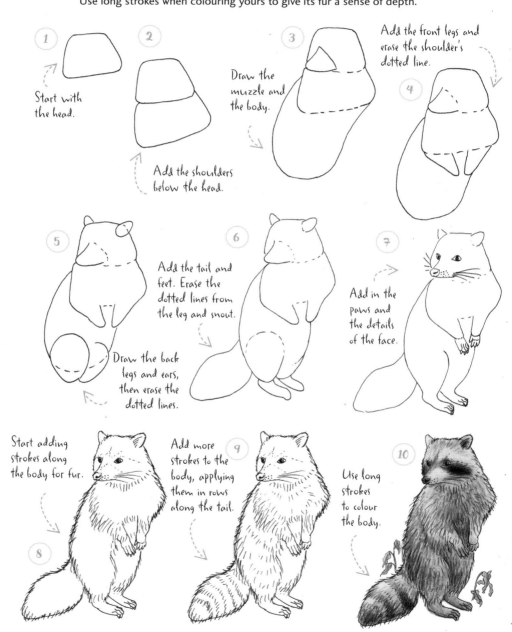

1 Start with the head.

2 Add the shoulders below the head.

3 Draw the muzzle and the body.

Add the front legs and erase the shoulder's dotted line.

4

5 Draw the back legs and ears, then erase the dotted lines.

Add the tail and feet. Erase the dotted lines from the leg and snout.

6

7 Add in the paws and the details of the face.

8 Start adding strokes along the body for fur.

9 Add more strokes to the body, applying them in rows along the tail.

10 Use long strokes to colour the body.

Red Squirrel

Squirrels are small animals with slender bodies, bushy tails and large eyes. They also love acorns, so make sure to give your squirrel one to nibble on.

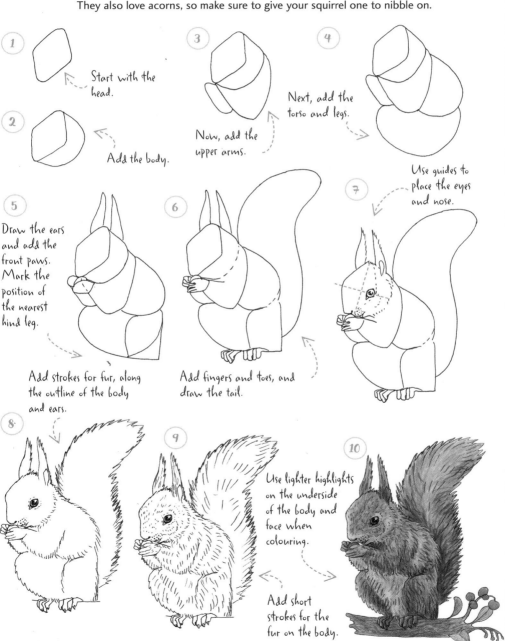

1 Start with the head.

2 Add the body.

3 Now, add the upper arms.

4 Next, add the torso and legs.

Use guides to place the eyes and nose.

5 Draw the ears and add the front paws. Mark the position of the nearest hind leg.

Add strokes for fur, along the outline of the body and ears.

6 Add fingers and toes, and draw the tail.

7

8

9 Use lighter highlights on the underside of the body and face when colouring.

10

Add short strokes for the fur on the body.

Elk

Elks have flat, box-shaped heads. They are simple
to draw – but the antlers might take some practice!

①

Start with the body.

②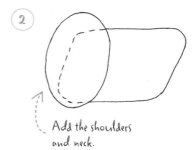

Add the shoulders
and neck.

③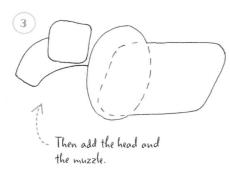

Then add the head and
the muzzle.

Join your shapes together. Add the hind leg
at the back.

④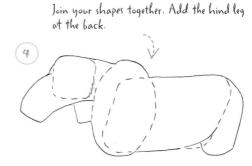

⑤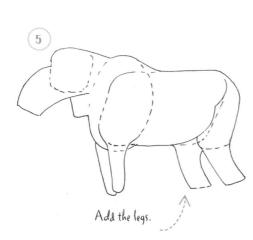

Add the legs.

Define the face,
removing the original
lines. Add the ears,
then start the antlers –
just add two curves to
start with.

⑥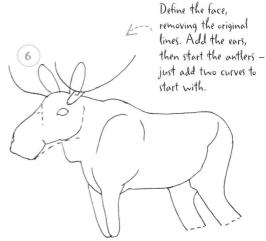

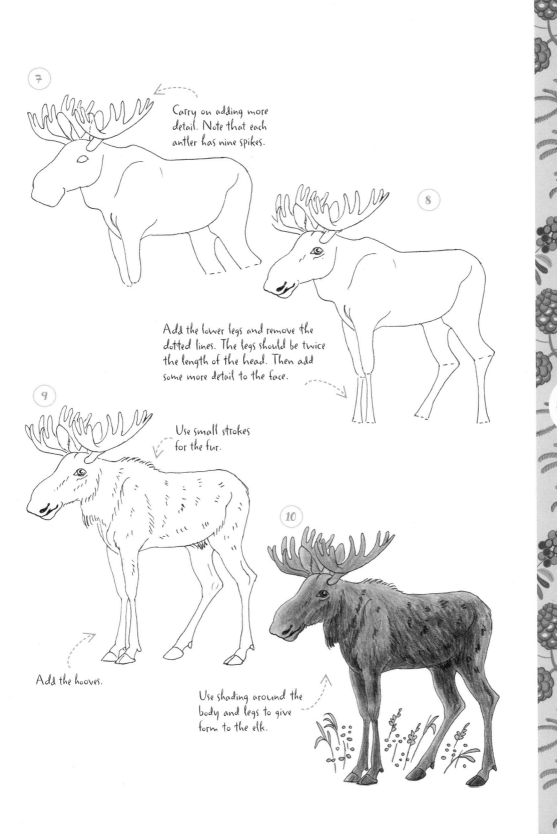

7

Carry on adding more detail. Note that each antler has nine spikes.

8

Add the lower legs and remove the dotted lines. The legs should be twice the length of the head. Then add some more detail to the face.

9

Use small strokes for the fur.

10

Add the hooves.

Use shading around the body and legs to give form to the elk.

Ladybird

The ladybird's body is simple to draw, but the face and legs are more complex.
You might want to practise these parts separately first.

①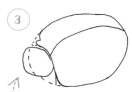

Create the body.

②

Add an arc at one end, where the torso and head will go.

③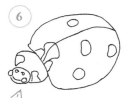

Draw the front torso and a curve across the back. Erase the dotted line.

④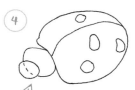

Add the head and draw uneven spots on the body.

⑤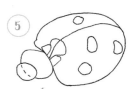

Fill in large and small rounded triangles on the body, near the torso.

⑥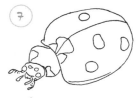

Draw in two eyes, a line for the mouth and 'R' shapes on either side of the head.

⑦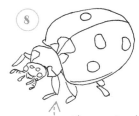

Draw the antennae and the mouthparts.

⑧

The upper legs have 'L'-shaped joints.

⑨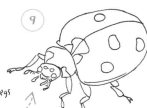

The lower legs are in two smaller parts.

⑩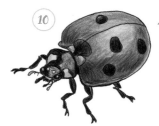

Ladybirds are brightly coloured. Fade the colour out at the top to give it a three-dimensional look.

Beaver

Beavers have powerful front teeth used for building and finding food. They have simple body shapes with webbed hind-feet and broad, scaly tails.

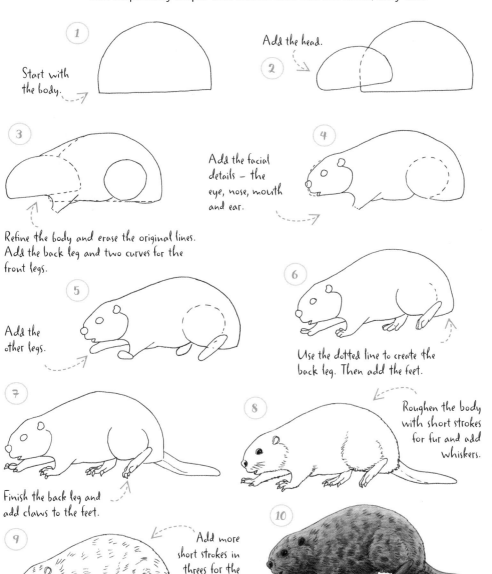

1 Start with the body.

2 Add the head.

3 Refine the body and erase the original lines. Add the back leg and two curves for the front legs.

4 Add the facial details – the eye, nose, mouth and ear.

5 Add the other legs.

6 Use the dotted line to create the back leg. Then add the feet.

7 Finish the back leg and add claws to the feet.

8 Roughen the body with short strokes for fur and add whiskers.

9 Add more short strokes in threes for the body fur.

10 Make sure you vary the shading between the top and bottom of the body to give the beaver form.

89

Grizzly Bear

Bears are easy to draw, as they are mostly made up of round shapes – apart from their box-shaped muzzles.

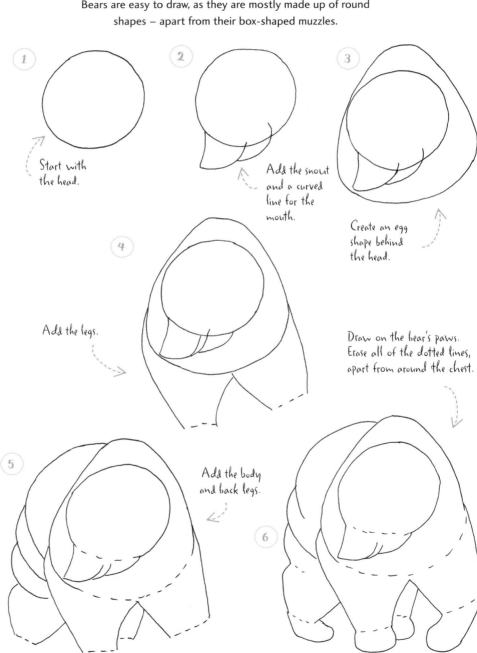

1. Start with the head.

2. Add the snout and a curved line for the mouth.

3. Create an egg shape behind the head.

4. Add the legs.

Draw on the bear's paws. Erase all of the dotted lines, apart from around the chest.

5. Add the body and back legs.

6.

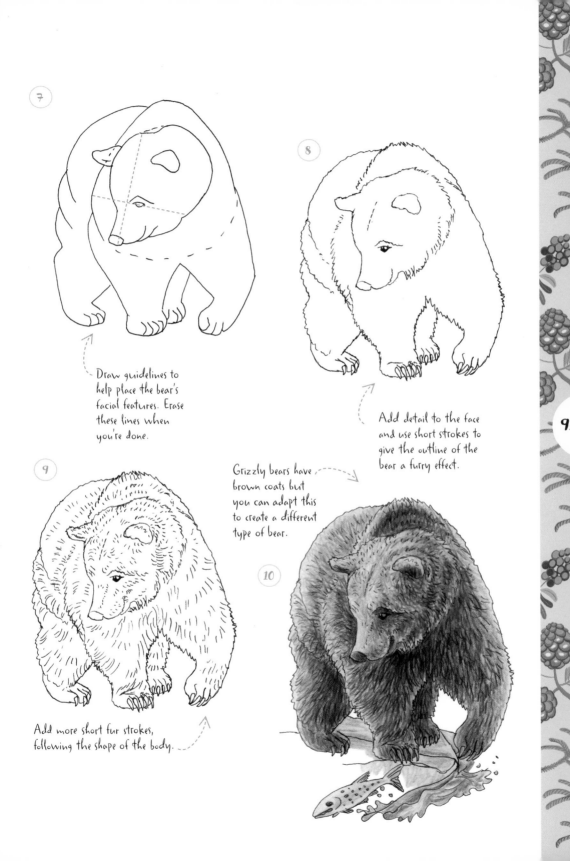

⑦

Draw guidelines to
help place the bear's
facial features. Erase
these lines when
you're done.

⑧

Add detail to the face
and use short strokes to
give the outline of the
bear a furry effect.

91

⑨

Grizzly bears have
brown coats but
you can adapt this
to create a different
type of bear.

⑩

Add more short fur strokes,
following the shape of the body.

Owl

Owls have distinctive feather patterns that blend into the trees they hide in when hunting at night. Owls have sharp talons and feathers adapted for silent flight.

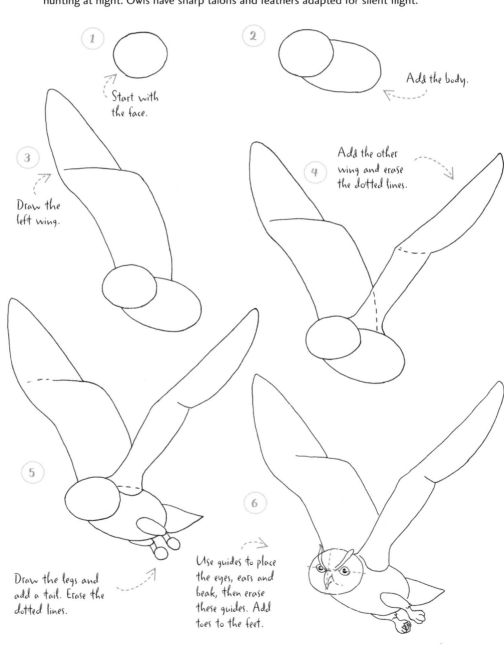

1 Start with the face.

2 Add the body.

3 Draw the left wing.

4 Add the other wing and erase the dotted lines.

5 Draw the legs and add a tail. Erase the dotted lines.

6 Use guides to place the eyes, ears and beak, then erase these guides. Add toes to the feet.

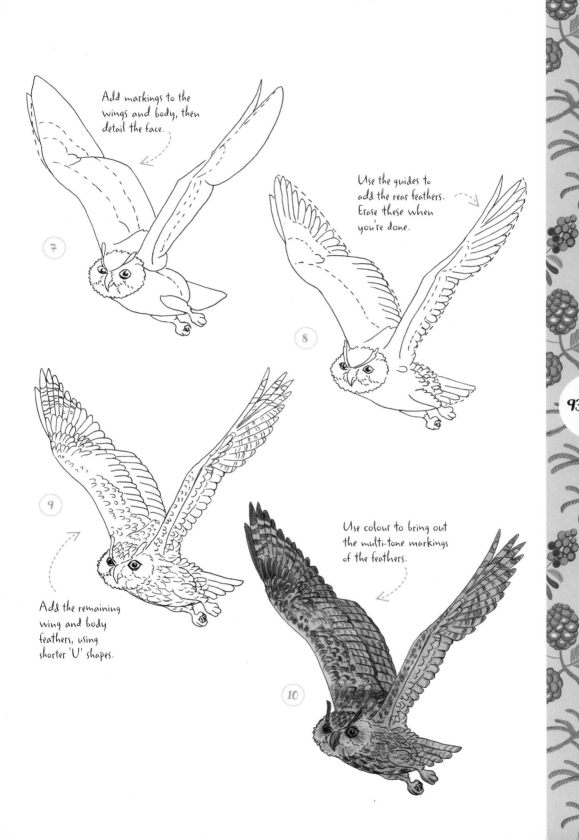

Add markings to the wings and body, then detail the face.

7

Use the guides to add the rear feathers. Erase these when you're done.

8

93

9

Add the remaining wing and body feathers, using shorter 'U' shapes.

Use colour to bring out the multi-tone markings of the feathers.

10

Skunk

Although not the feature they are best known for, skunks are very furry!
Make sure you use distinct lines when colouring, to really bring out this feature.

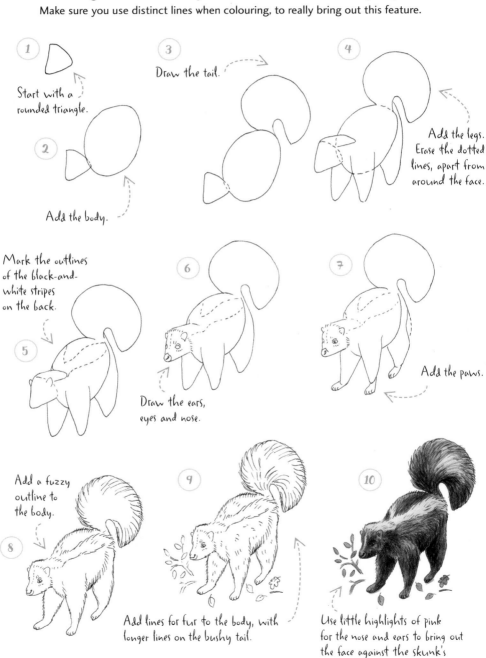

1

Start with a
rounded triangle.

2

Add the body.

3

Draw the tail.

4

Add the legs.
Erase the dotted
lines, apart from
around the face.

5

Mark the outlines
of the black-and-
white stripes
on the back.

6

Draw the ears,
eyes and nose.

7

Add the paws.

8

Add a fuzzy
outline to
the body.

9

Add lines for fur to the body, with
longer lines on the bushy tail.

10

Use little highlights of pink
for the nose and ears to bring out
the face against the skunk's
black-and-white markings.

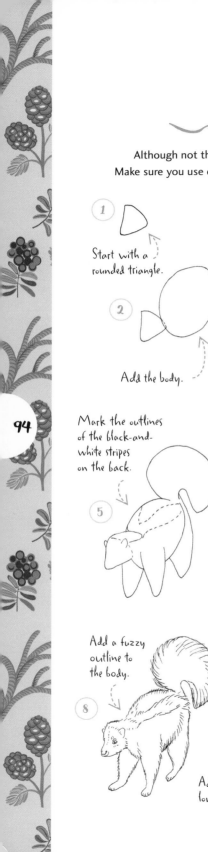

94

Bat

With their forelimbs adapted as wings and long, spread-out digits, you may flinch at drawing a bat! However, using simple geometric shapes, you'll find it's really easy.

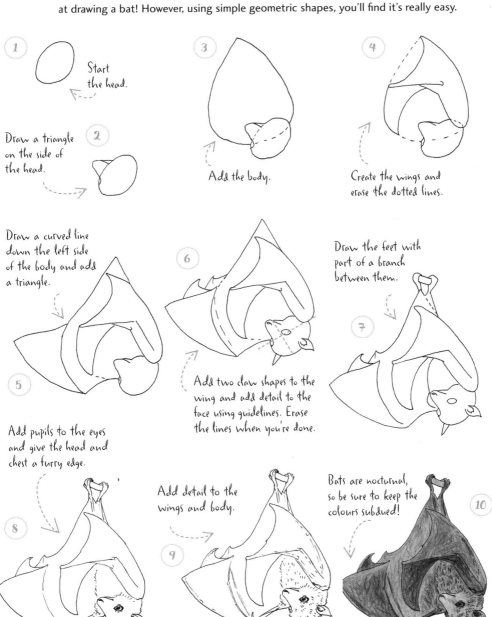

1 Start the head.

2 Draw a triangle on the side of the head.

3 Add the body.

4 Create the wings and erase the dotted lines.

5 Draw a curved line down the left side of the body and add a triangle.

6 Add two claw shapes to the wing and add detail to the face using guidelines. Erase the lines when you're done.

7 Draw the feet with part of a branch between them.

8 Add pupils to the eyes and give the head and chest a furry edge.

9 Add detail to the wings and body.

10 Bats are nocturnal, so be sure to keep the colours subdued!

Butterfly

Butterflies are beautiful insects with brightly coloured fluttering wings. They have symmetrical bodies, so be careful to keep their four scale-covered wings the same on both sides.

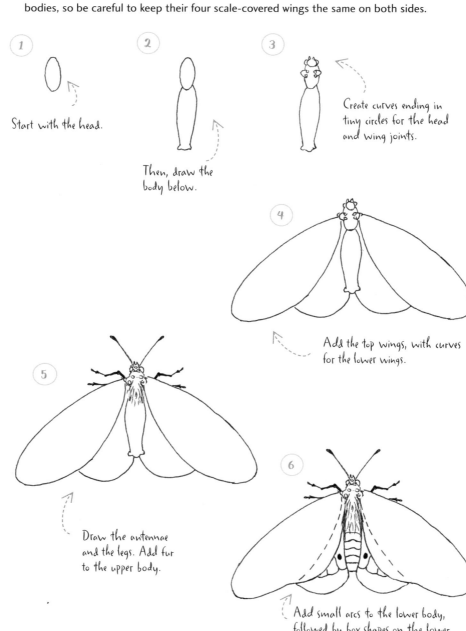

1 Start with the head.

2 Then, draw the body below.

3 Create curves ending in tiny circles for the head and wing joints.

4 Add the top wings, with curves for the lower wings.

5 Draw the antennae and the legs. Add fur to the upper body.

6 Add small arcs to the lower body, followed by box shapes on the lower wings. Erase the dotted lines.

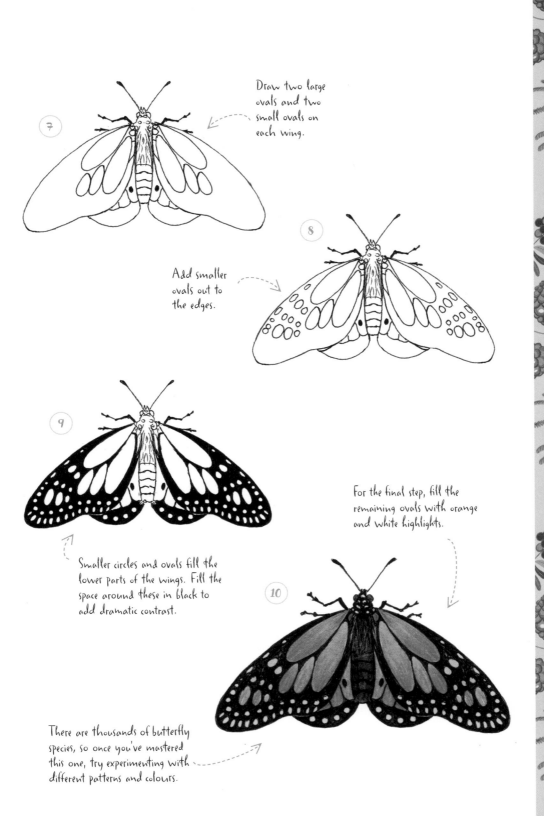

Draw two large ovals and two small ovals on each wing.

Add smaller ovals out to the edges.

For the final step, fill the remaining ovals with orange and white highlights.

Smaller circles and ovals fill the lower parts of the wings. Fill the space around these in black to add dramatic contrast.

There are thousands of butterfly species, so once you've mastered this one, try experimenting with different patterns and colours.

River Otter

Otters have sleek fur, which becomes much darker when they are wet.
Feel free to darken the fur in your drawing.

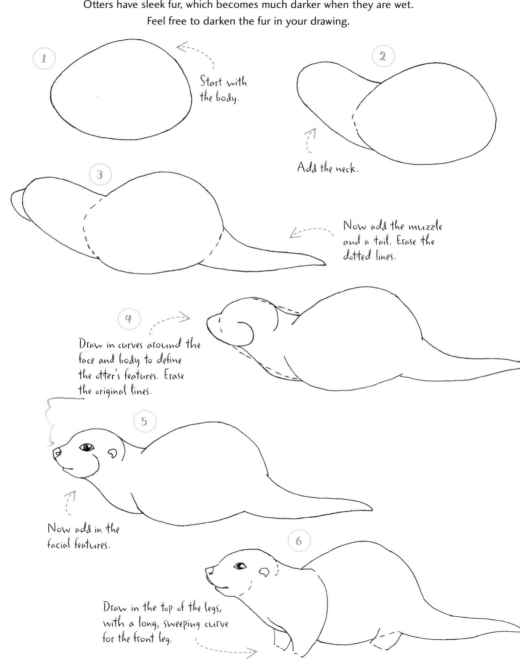

1 Start with the body.

2 Add the neck.

3 Now add the muzzle and a tail. Erase the dotted lines.

4 Draw in curves around the face and body to define the otter's features. Erase the original lines.

5 Now add in the facial features.

6 Draw in the top of the legs, with a long, sweeping curve for the front leg.

98

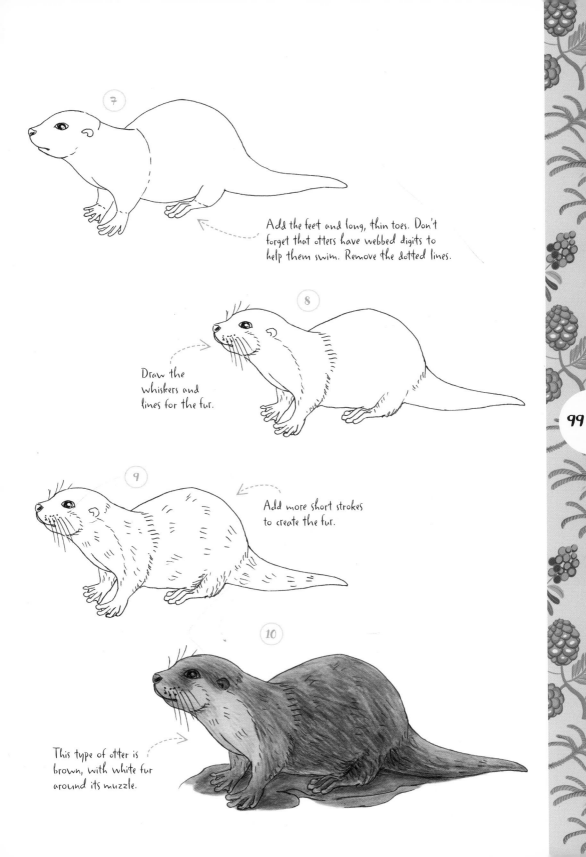

Add the feet and long, thin toes. Don't forget that otters have webbed digits to help them swim. Remove the dotted lines.

Draw the whiskers and lines for the fur.

Add more short strokes to create the fur.

This type of otter is brown, with white fur around its muzzle.

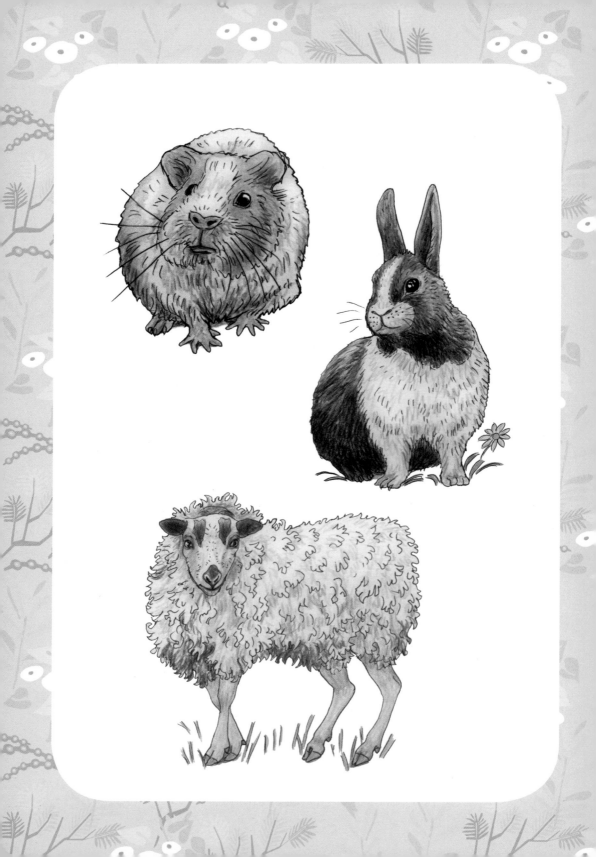

Farm Animals & Pets

Cow

Cows are angular animals, which makes them easy to draw. It is a good idea to use guidelines to help you get the proportions right.

1

Start with the head.

2

Add the muzzle and shave the jawline.

3

Add the front of the torso. Add detail to the muzzle by adding the nose and a dip to the chin.

4

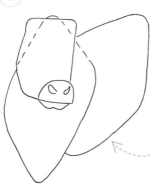

Draw the rest of the body. Then erase the dotted lines on the face.

5

Shape the head and body, following the guidelines, and add a curve for the top of the tail. Erase the remaining dotted lines.

6

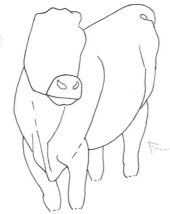

Draw the top of the legs.

Add guidelines to help you draw the face; this will keep everything at the right angle. Erase the lines when you're done.

7

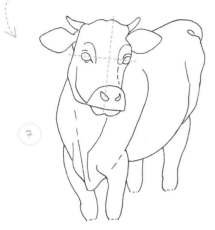

3

2

1

0

8

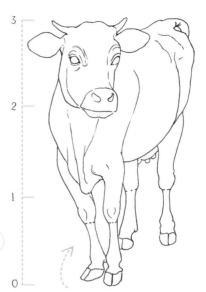

Add the lower legs. The distance from the top of the head to the top of the legs should be the same as the whole leg length. Erase the dotted lines.

Add short strokes for the hair on the head and ears, draw wavy lines for the tail, and add pupils to the eyes.

9

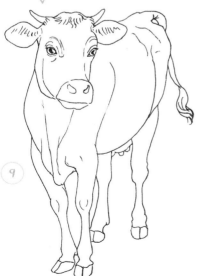

10

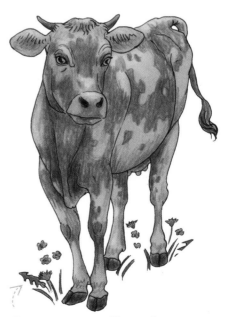

Cows come in many different colours, so you can use a single colour for the coat or create a unique pattern like the one in this drawing.

Donkey

Donkeys have a similar shape to a zebra (page 35), so keep the body stout and fat with short legs. Don't forget to make your donkey's ears extra large.

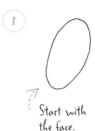

1

Start with the face.

2

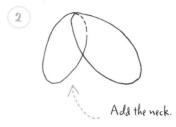

Add the neck.

3

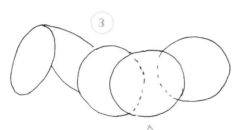

Draw three overlapping circles for the body at the base of the neck.

4

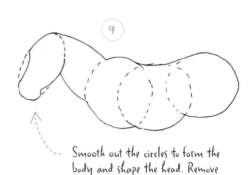

Smooth out the circles to form the body and shape the head. Remove the dotted lines from the face.

5

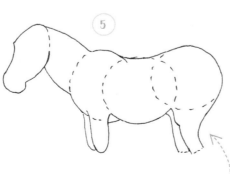

Add the thighs at the front and back. Erase the dotted lines.

Draw the ears, a line for the mouth and the nostril.

6

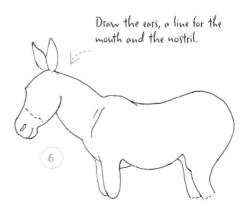

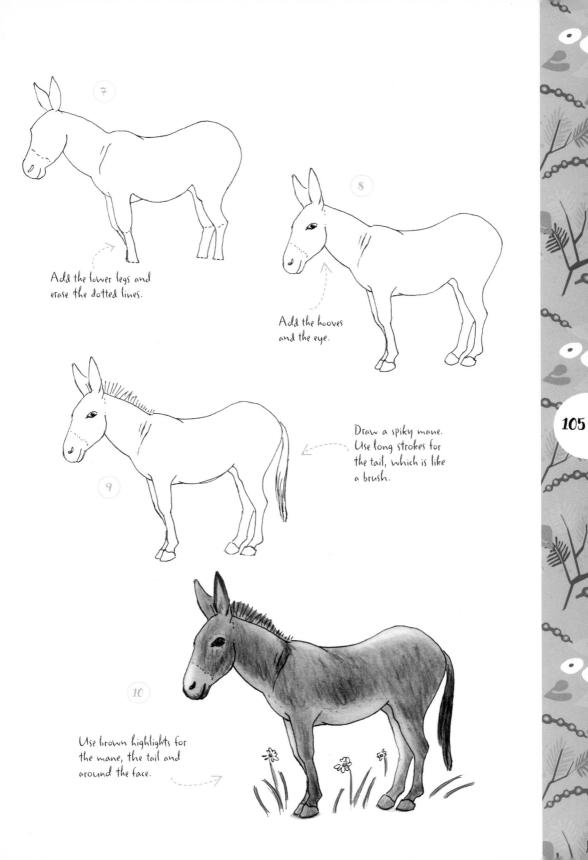

Add the lower legs and erase the dotted lines.

Add the hooves and the eye.

Draw a spiky mane. Use long strokes for the tail, which is like a brush.

Use brown highlights for the mane, the tail and around the face.

105

Rabbit

Rabbits are known for their large ears; some rabbits even have lopped ears. Once you've mastered this classic rabbit, why not try some ear variations?

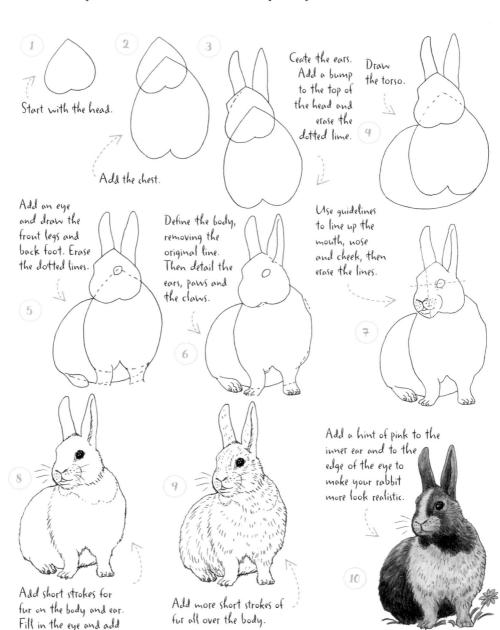

① Start with the head.

② Add the chest.

③ Ceate the ears. Add a bump to the top of the head and erase the dotted lime.

Draw the torso.

④

⑤ Add an eye and draw the front legs and back foot. Erase the dotted lines.

⑥ Define the body, removing the original line. Then detail the ears, paws and the claws.

⑦ Use guidelines to line up the mouth, nose and cheek, then erase the lines.

⑧ Add short strokes for fur on the body and ear. Fill in the eye and add whiskers to the cheeks.

⑨ Add more short strokes of fur all over the body.

⑩ Add a hint of pink to the inner ear and to the edge of the eye to make your rabbit more look realistic.

Sheep

Sheep have a simple body shape but are very woolly – make sure
you add plenty of curly lines to give your sheep volume.

1 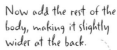 Start with
the face.

2 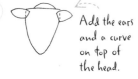 Add the ears
and a curve
on top of
the head.

3 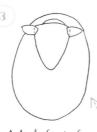 Add the front of
the body.

Now add the rest of the
body, making it slightly
wider at the back.

4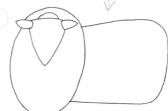

5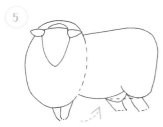

Draw the upper legs
and shape the belly.
Erase the dotted line
under the body.

6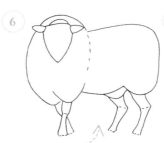

Add the lower legs and
erase the dotted lines here.

7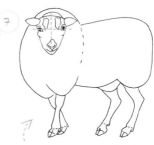

Use guides to position the facial
features, then erase these lines.
Add the hooves. Erase the dotted
line on the body.

8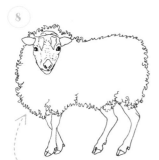

Add flame-like curly lines around
the outline of the body and some
very short strokes to the face.

9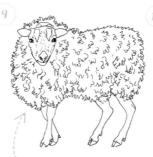

Add more flame shapes to the
body. They should all be in
similar directions.

10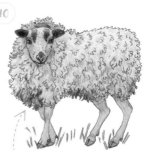

Using dark shades on the
sheep's face will contrast well
with the rest of the body.

Dog

Dogs have distinctive and expressive faces. Make sure that you spend time getting the facial features right to capture this.

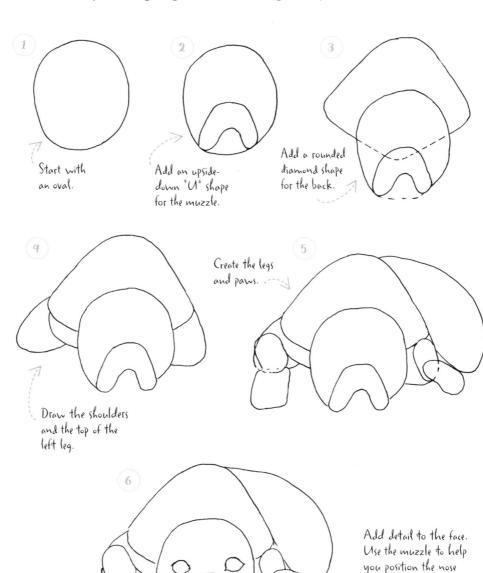

1
Start with an oval.

2
Add an upside-down "U" shape for the muzzle.

3
Add a rounded diamond shape for the back.

4
Draw the shoulders and the top of the left leg.

5
Create the legs and paws.

6
Add detail to the face. Use the muzzle to help you position the nose and mouth.

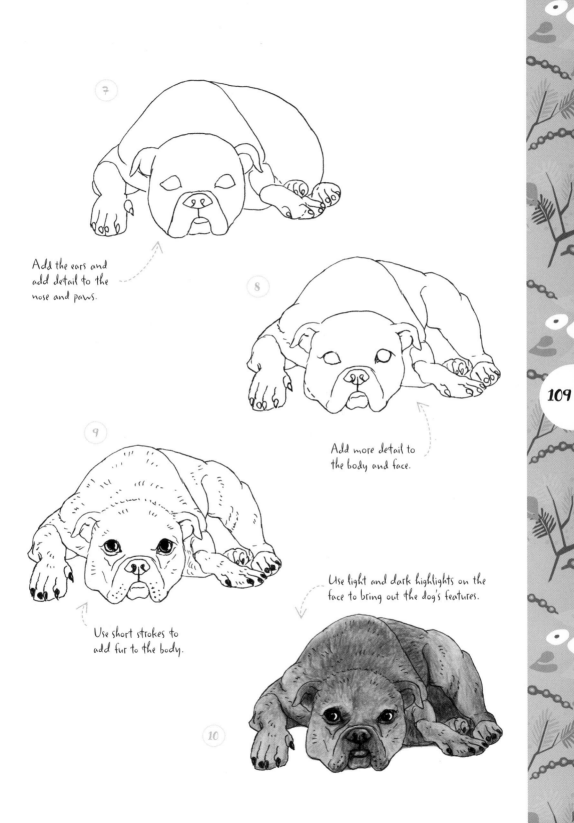

Add the ears and
add detail to the
nose and paws.

Add more detail to
the body and face.

Use short strokes to
add fur to the body.

Use light and dark highlights on the
face to bring out the dog's features.

109

Budgerigar

The budgerigar – also called a budgie – is a small, long-tailed parakeet. To make it look realistic, spend time getting the feather shapes in the wings right.

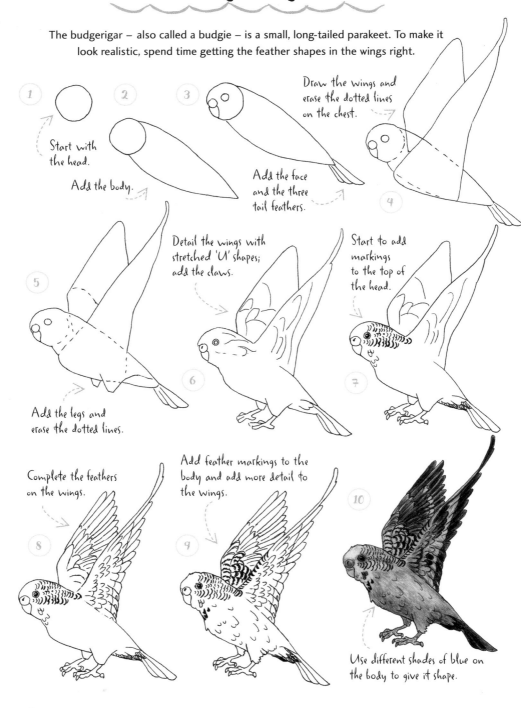

1

Start with the head.

2

Add the body.

3

Add the face and the three tail feathers.

Draw the wings and erase the dotted lines on the chest.

4

5

Add the legs and erase the dotted lines.

Detail the wings with stretched 'U' shapes; add the claws.

6

Start to add markings to the top of the head.

7

Complete the feathers on the wings.

8

Add feather markings to the body and add more detail to the wings.

9

10

Use different shades of blue on the body to give it shape.

Guinea Pig

Guinea pigs are large, friendly rodents. They are inquisitive, too – try to capture this expression in your drawing.

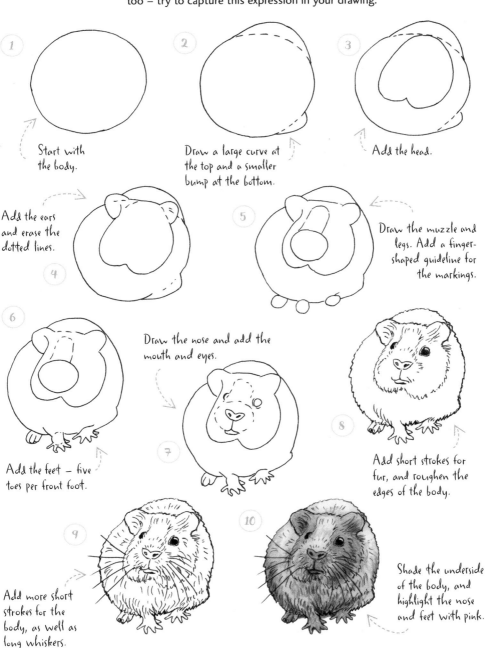

1 Start with the body.

2 Draw a large curve at the top and a smaller bump at the bottom.

3 Add the head.

Add the ears and erase the dotted lines.

4

5 Draw the muzzle and legs. Add a finger-shaped guideline for the markings.

6

Draw the nose and add the mouth and eyes.

7

Add the feet – five toes per front foot.

8 Add short strokes for fur, and roughen the edges of the body.

9 Add more short strokes for the body, as well as long whiskers.

10 Shade the underside of the body, and highlight the nose and feet with pink.

Pig

Pigs are known for their pointy ears, curly tails and flat noses.
Guides will help you get the facial features right.

①

Start with the head.

②

Add the neck, following the same curve as the head.

③

Draw the snout, the chin and the mouth. Erase the dotted lines.

④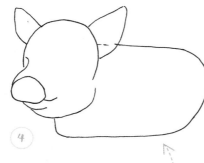

Add the ears and the body. Erase the dotted line in the ear.

⑤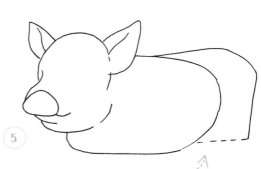

Extend the back of the body and add curved lines to the ears.

⑥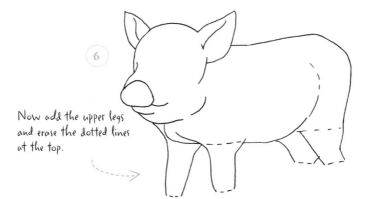

Now add the upper legs and erase the dotted lines at the top.

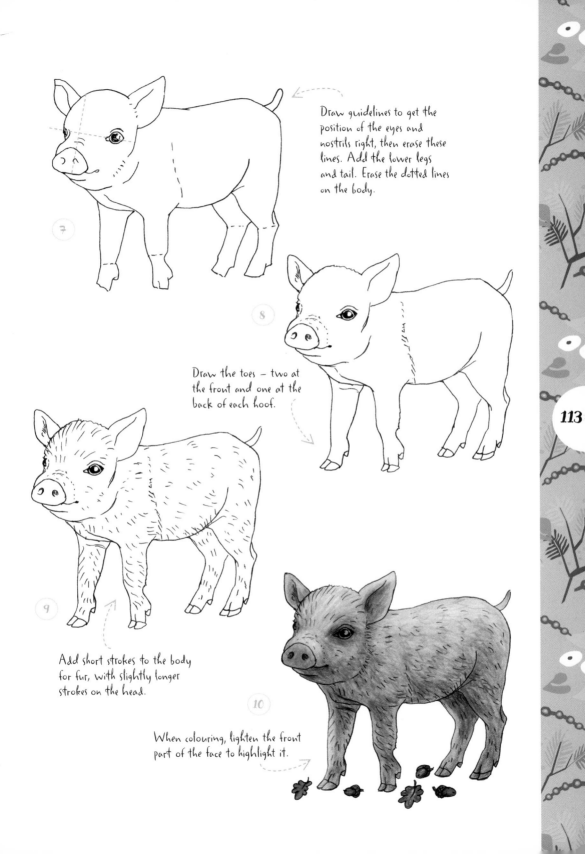

Draw guidelines to get the position of the eyes and nostrils right, then erase these lines. Add the lower legs and tail. Erase the dotted lines on the body.

7

8

Draw the toes – two at the front and one at the back of each hoof.

9

Add short strokes to the body for fur, with slightly longer strokes on the head.

10

When colouring, lighten the front part of the face to highlight it.

Camel

Camels are known for their long legs and humped backs. Once you've mastered the instructions below, you can try drawing a camel with two humps.

① Start with the centre of the body.

②
Add the rest of the body.

Draw the neck.

③

④
Add a curve to define the belly and refine the shape of the body. Remove the dotted lines when you're done.

Add the tail and the head.

⑤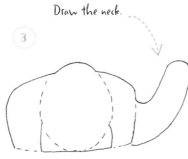

⑥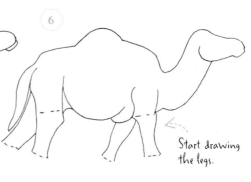
Start drawing the legs.

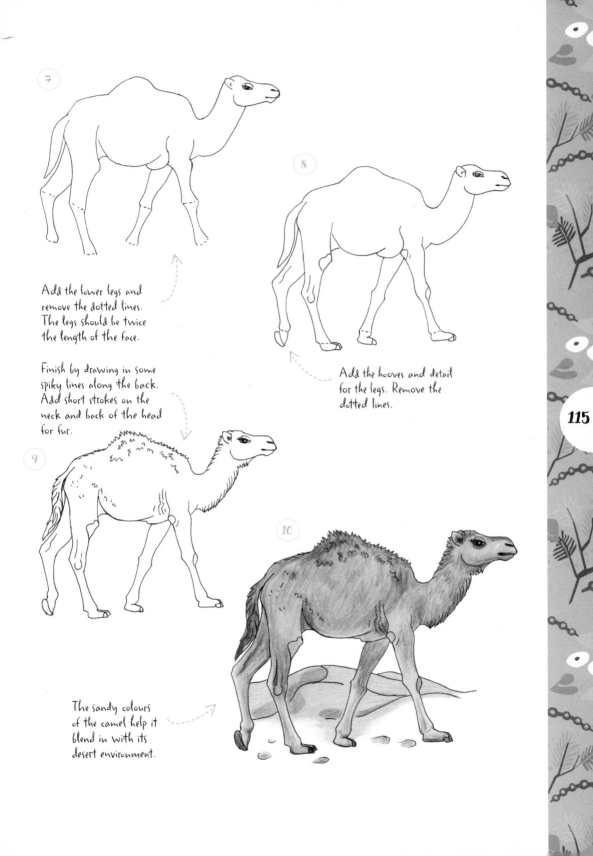

⑦

Add the lower legs and
remove the dotted lines.
The legs should be twice
the length of the face.

⑧

Finish by drawing in some
spiky lines along the back.
Add short strokes on the
neck and back of the head
for fur.

Add the hooves and detail
for the legs. Remove the
dotted lines.

⑨

115

⑩

The sandy colours
of the camel help it
blend in with its
desert environment.

Goat

Noted for their lively behaviour, goats are highly intelligent creatures.
They are bony and angular, which helps them to climb in their native rocky habitats.

1 Start with the face.

Add a bump for the left horn and erase the dotted line.

2

3 Draw the neck.

Add the body.

4

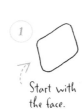

5 Add the ears, horns and the muzzle. Remove the dotted lines from the body.

6 Draw the upper legs and add a short, fluffy tail. Remove the dotted lines.

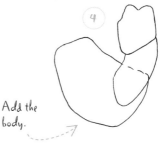

7 Draw the nose and mouth. Use the guide to add lower legs then remove the dotted lines.

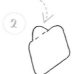

4

3

2

1

0

8 Add the hooves. Draw guides to help place the eyes.

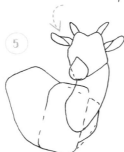

9 Draw short lines on the body for fur.

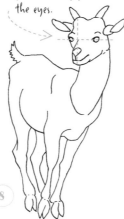

10 A dash of pink for the ears, nose and mouth helps the face stand out.

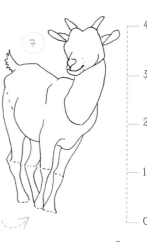

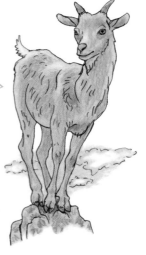

Snake

Snakes are all curves! As long as you get those curves right, you shouldn't find it too difficult to draw one. The diamond-grid guidelines will help with the scales.

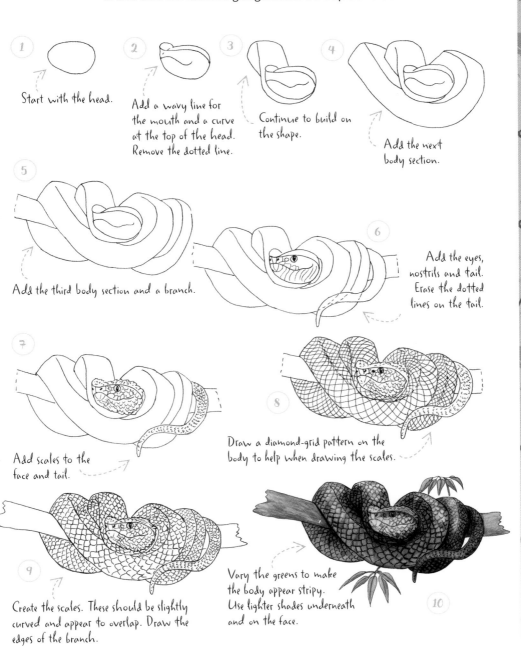

1 Start with the head.

2 Add a wavy line for the mouth and a curve at the top of the head. Remove the dotted line.

3 Continue to build on the shape.

4 Add the next body section.

5 Add the third body section and a branch.

6 Add the eyes, nostrils and tail. Erase the dotted lines on the tail.

7 Add scales to the face and tail.

8 Draw a diamond-grid pattern on the body to help when drawing the scales.

9 Create the scales. These should be slightly curved and appear to overlap. Draw the edges of the branch.

10 Vary the greens to make the body appear stripy. Use lighter shades underneath and on the face.

Horse

Horses come in a range of colourings. This one has a dark muzzle and legs that contrast with the brown of its body.

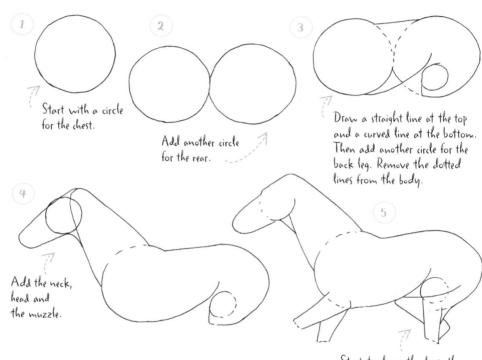

1. Start with a circle for the chest.

2. Add another circle for the rear.

3. Draw a straight line at the top and a curved line at the bottom. Then add another circle for the back leg. Remove the dotted lines from the body.

4. Add the neck, head and the muzzle.

5. Start to draw the legs, then remove the dotted lines from the legs and face.

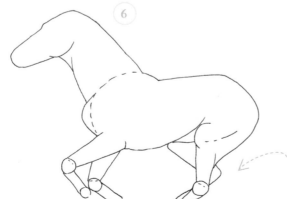

6. Draw the knees and add the lower legs. Make sure that the back legs curve in and out slightly. Remove the dotted lines from the body and the circles from the legs.

Add definition to the legs, to show the muscular shape of the horse. Then add the hooves.

Draw a grid and use the guide above to compare where the legs are in your drawing with where they are in this one. Erase it when you're done.

7

8 Draw the face. Create teardrops for the nose and eye, a line for the mouth, and two teardrops on stalks for the ears.

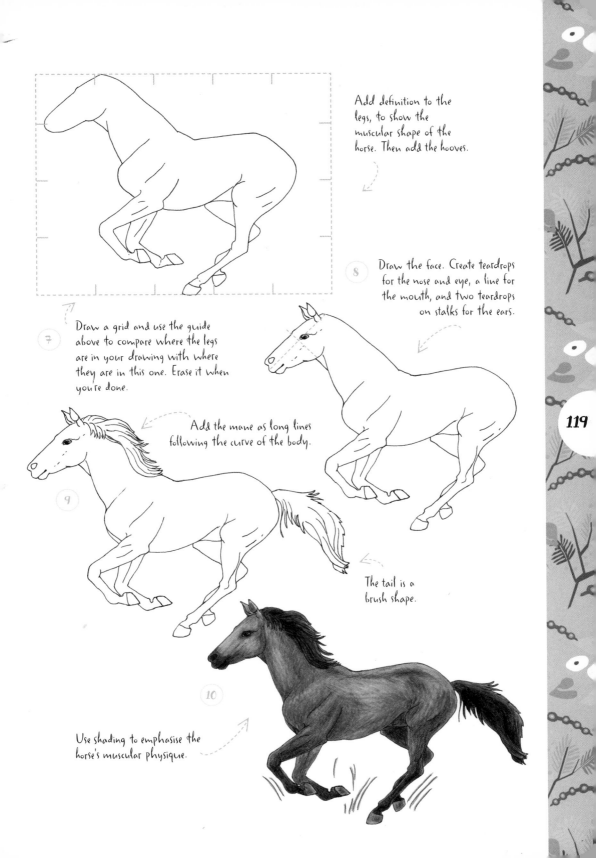

119

Add the mane as long lines following the curve of the body.

9

The tail is a brush shape.

10

Use shading to emphasise the horse's muscular physique.

Mouse

These cute critters are known for their big ears and long tails. Mice's limbs are mostly hidden beneath their fur – apart from when they're nibbling on something!

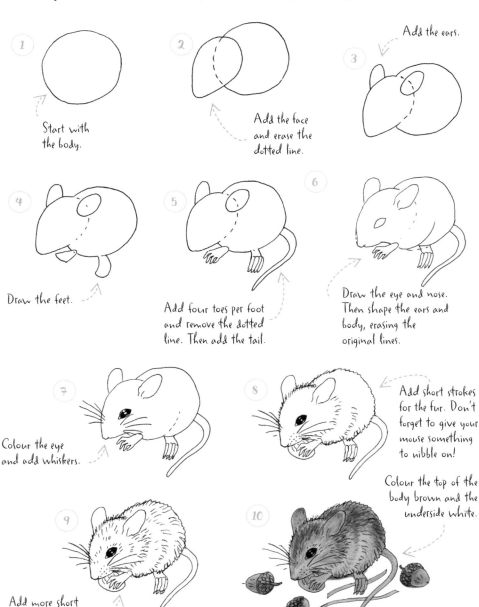

1 Start with the body.

2 Add the face and erase the dotted line.

3 Add the ears.

4 Draw the feet.

5 Add four toes per foot and remove the dotted line. Then add the tail.

6 Draw the eye and nose. Then shape the ears and body, erasing the original lines.

7 Colour the eye and add whiskers.

8 Add short strokes for the fur. Don't forget to give your mouse something to nibble on!

Colour the top of the body brown and the underside white.

9 Add more short strokes to the body.

10

Duck

This is a classic pose for a duck in flight. Be careful to get the proportions right when drawing the feathers.

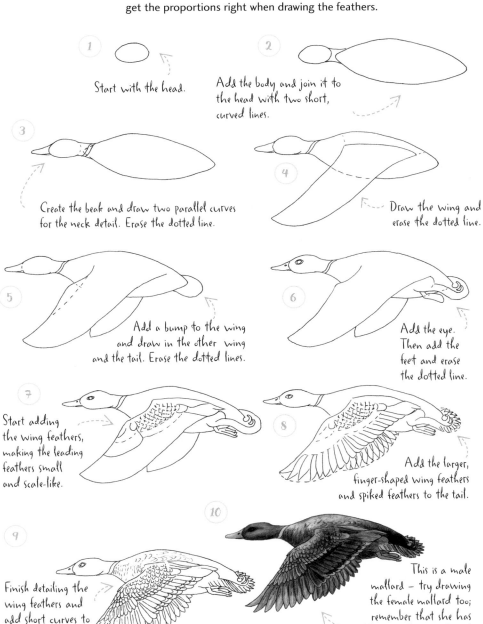

1 Start with the head.

2 Add the body and join it to the head with two short, curved lines.

3 Create the beak and draw two parallel curves for the neck detail. Erase the dotted line.

4 Draw the wing and erase the dotted line.

5 Add a bump to the wing and draw in the other wing and the tail. Erase the dotted lines.

6 Add the eye. Then add the feet and erase the dotted line.

7 Start adding the wing feathers, making the leading feathers small and scale-like.

8 Add the larger, finger-shaped wing feathers and spiked feathers to the tail.

9 Finish detailing the wing feathers and add short curves to the body.

10 This is a male mallard – try drawing the female mallard too; remember that she has different colour markings!

Llama

Llamas are tall animals with long, banana-shaped ears. Use longer strokes to emphasise the llama's soft, shaggy fur.

1

Start with the head.

2

Add the muzzle and erase the dotted line.

3

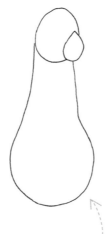

Draw the neck.

4

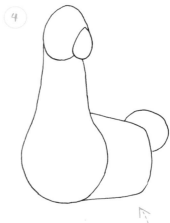

Add the torso and the tail.

5

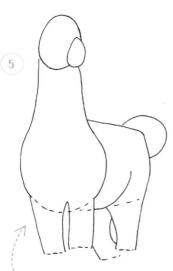

Draw the upper legs as slightly narrowing lines. Erase the dotted lines along the body.

6

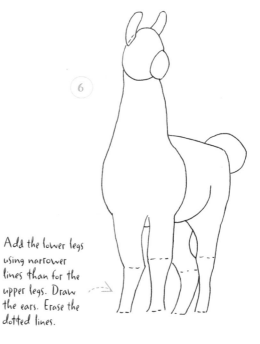

Add the lower legs using narrower lines than for the upper legs. Draw the ears. Erase the dotted lines.

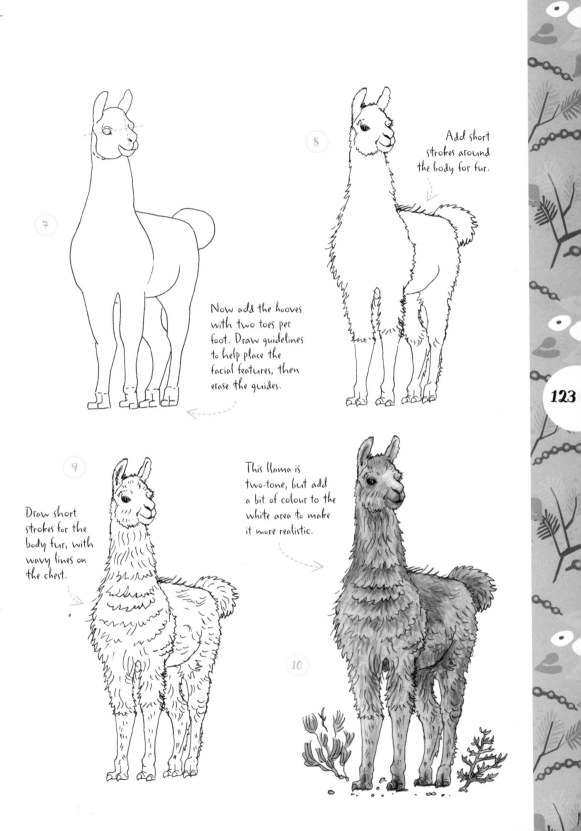

Now add the hooves with two toes per foot. Draw guidelines to help place the facial features, then erase the guides.

Add short strokes around the body for fur.

Draw short strokes for the body fur, with wavy lines on the chest.

This llama is two-tone, but add a bit of colour to the white area to make it more realistic.

Cat

Cats are never happier than when they are curled up in a ball asleep! For this drawing, you will start with an oval shape and modify it to bring out the shape of a cat at rest.

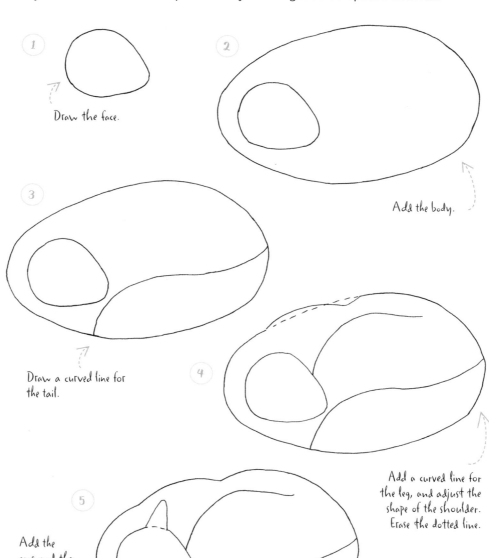

1 Draw the face.

2 Add the body.

3 Draw a curved line for the tail.

4 Add a curved line for the leg, and adjust the shape of the shoulder. Erase the dotted line.

5 Add the ears and the front paw. Erase the dotted lines.

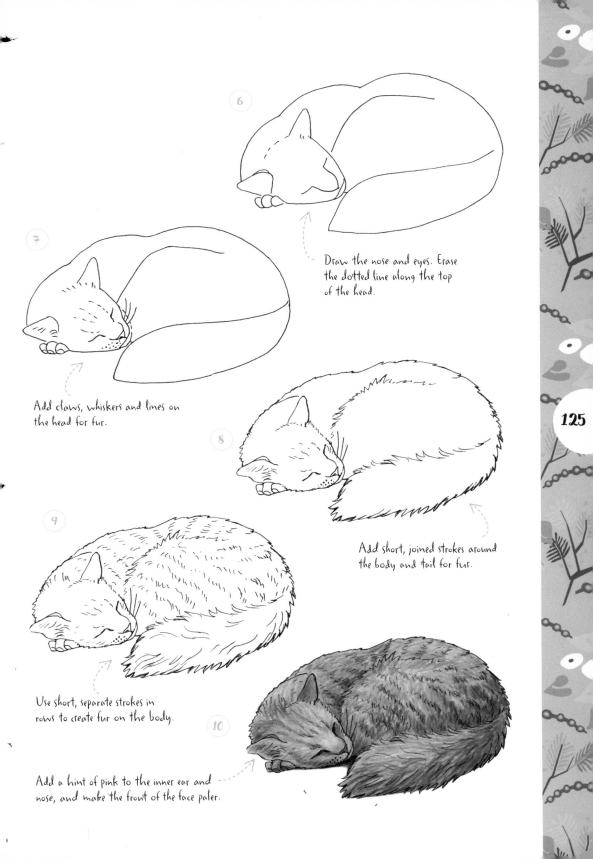

6

Draw the nose and eyes. Erase
the dotted line along the top
of the head.

7

Add claws, whiskers and lines on
the head for fur.

8

Add short, joined strokes around
the body and tail for fur.

9

Use short, separate strokes in
rows to create fur on the body.

10

Add a hint of pink to the inner ear and
nose, and make the front of the face paler.

Chicken

To draw a chicken, you simply need to use three overlapping half-circles.
The only straight lines required are for the legs.

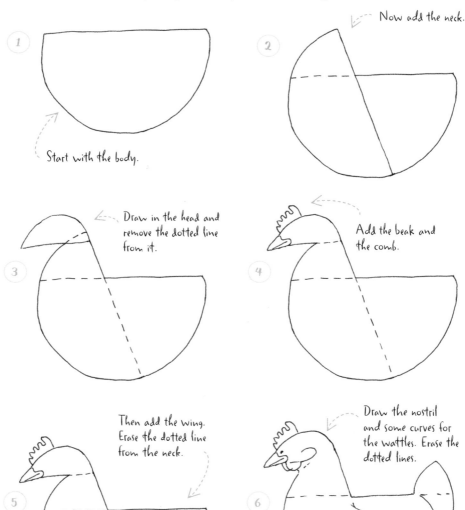

1 Start with the body.

2 Now add the neck.

3 Draw in the head and remove the dotted line from it.

4 Add the beak and the comb.

5 Then add the wing. Erase the dotted line from the neck.

6 Draw the nostril and some curves for the wattles. Erase the dotted lines.

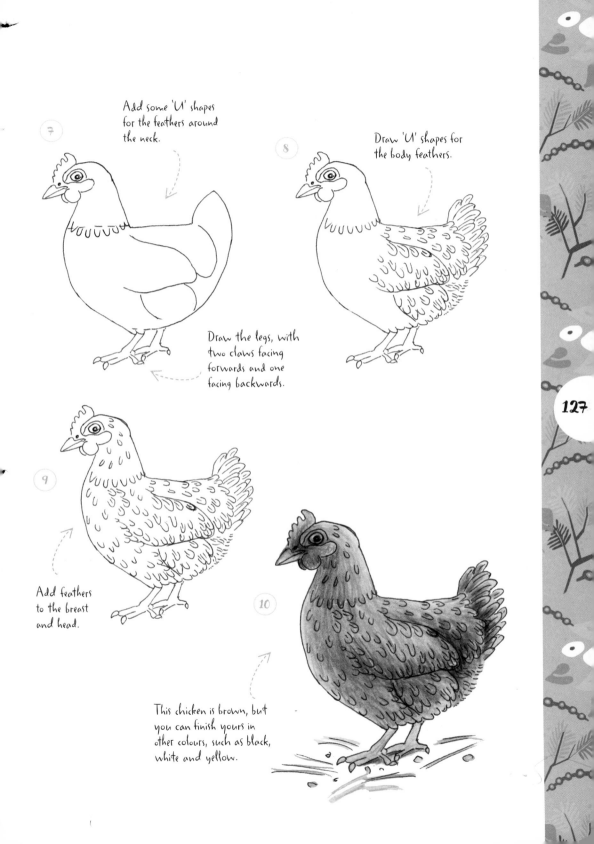

Add some 'U' shapes for the feathers around the neck.

7

8

Draw 'U' shapes for the body feathers.

Draw the legs, with two claws facing forwards and one facing backwards.

127

9

10

Add feathers to the breast and head.

This chicken is brown, but you can finish yours in other colours, such as black, white and yellow.

About the artist

Heather Kilgour is a London-based illustrator, specialising in children's illustration. Heather has been the featured illustrator in *Words &Pictures* online magazine and is a member of the SCBWI's Illustration Committee.

To see more of Heather's work visit her at heatherkilgour.com.

Acknowledgements

Thank you to my wonderful partner, Perraine – it would never have got done without you! And to Layn Marlow, who is both a master of her craft and generous with her advice.